the BEATLES
IN POSTERS

the BEATLES
IN POSTERS

A COLLECTION OF CONCERT ARTWORK BY

TONY BOOTH

The
History
Press

First published 2017

The History Press
The Mill, Brimscombe Port
Stroud, Gloucestershire, GL5 2QG
www.thehistorypress.co.uk

British Library Cataloguing in Publication Data.
A catalogue record for this book is available from the
British Library.

ISBN 978 0 7509 8378 5

Typesetting and origination by The History Press
Printed in Turkey by Imak

Introduction

TONY BOOTH was a world-renowned poster artist who was most famous for the work he did for the Beatles, the Cavern Club and various musical artists during the 1950s and 1960s. His work is an iconic part of the Merseybeat era and he played an important part in the success of the Beatles.

Tony was born in England in 1933. His parents lived in a country house in Flockton, near Huddersfield in Yorkshire. Tony's father was a naval officer and regularly sailed between Liverpool and Africa. To move closer to his father's work, Tony's mother found a suitable family home in Wallasey village, which is situated 30 minutes from where his father's ship used to depart from. Tony was 5 years old when they moved to Merseyside.

At the age of 15, Tony earned himself a scholarship to study commercial art at Wallasey College of Art. His interest in creative lettering and design started before he left school. One of his teachers had been a poster artist himself and taught Tony how to use a one-stroke poster brush.

Shortly after starting his studies, Tony was offered his first job in a commercial art studio that also produced signs and posters. The man who gave Tony this job was Alan Norman Parry, who was the finest creative lettering artist in England during

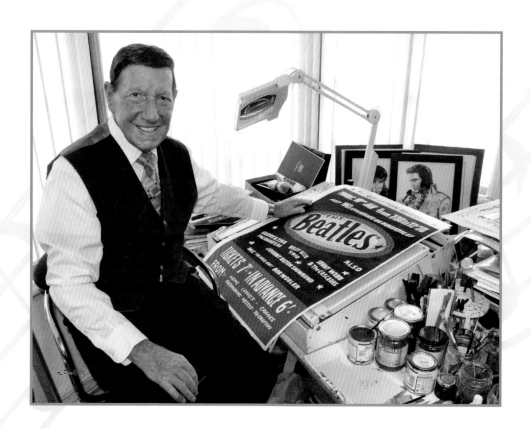

the 1940s and 1950s. He gave Tony the best possible apprenticeship to kick-start his career.

In 1951, Tony was 18 years old and was called up to do National Service in the Royal Air Force, but instead of going on courses and parades with other recruits, he was given the job of sign-writing noticeboards, and painting crests on vehicles and aircraft for the entire air force base.

After his discharge from the RAF in 1953, Tony was offered a well-paid job as a lettering artist in a large Liverpool-based advertising agency but continued to do freelance poster work with his mentor Alan Parry over the next twenty years. It was when he was working as a freelance poster writer that he first met Alan Sytner in 1956. Tony had produced flyers and artwork for a jazz club Alan had opened in Croxteth. By the end of the year, Tony was commissioned to produce the famous 'grand opening' of the Cavern Club for January 1957. This is the first poster in this book. It was at this point that Tony's reputation as 'gig' poster artist began to grow within the local music community.

In the late 1950s, Tony moved to a large commercial art studio in Whitechapel in Liverpool city centre. He was a 5-minute walk from the Cavern Club and next door to Brian Epstein's NEMS Enterprises Record Store. Tony was already working

for Brian Epstein's family furniture business producing posters and 'point of sale' material. When Brian Epstein took an interest in the Beatles and rock 'n' roll, he approached Tony to produce all the posters and lettering needed to promote all his events, and Tony found himself in the middle of the birth of the Merseybeat music explosion.

During the Beatles' the rise to fame, Tony produced hundreds of hand-painted posters that history has shown to play a big part in the success of this band and other groups. Tony would be paid 5 shillings for each poster. That's 25 pence today. It was good money in the early 1960s, and Brian once said to Tony, 'You're earning more than the boys,' referring to the Beatles; they both laughed. Tony would hand paint up to six posters if needed. If more were required then they would be screen-printed. His original poster would be carved up to make stencils as part of the printing process. After each event had passed, Tony's posters would simply be disposed of and replaced with new ones for the following concerts. Liverpool during the 1960s was a very exciting place to be a part of and the memories of the Beatles and the Merseybeat sound will live on forever through Tony's artwork.

In 2013, a poster made by Tony for a big event promoted by Brian Epstein at the Tower Ballroom, featuring Little Richard, was uncovered by builders during

renovation at Bidston station on Merseyrail Wirral line. Although it was only a printed copy, this was a huge discovery and it is now on display at the Beatles Story Museum in Liverpool.

Tony never stopped working – even in his 80s he spent his time reproducing his original posters, which he donated to charities, museums and local clubs, and also supplied them to friends and fans. 2016 was a very busy year for Tony as he reproduced a large number of his original posters, which can be seen in this book. The year started with a BBC documentary on Tony, which created such a buzz about his work that, with the help of his family, he hosted the very first art exhibition of his work on Mathew Street as part of International Beatles Week. This was the first time a large selection of his posters was seen under one roof.

Unfortunately on 11 January 2017 Tony passed away peacefully after a long battle with cancer. Remarkably, he had worked right up to his death and actually completed his final piece of work, which was the opening title image for a BBC documentary, to celebrate the Cavern Club's 60th anniversary, on the morning before he left for hospital. It was very fitting that his first and last ever work was for the Cavern Club. Spanning a career of more than sixty years, Tony has left behind an iconic style that defines an era of both art and music. His legacy will forever live on in history.

Cavern Club, Liverpool
Wednesday 16 January 1957

Tony Booth, the poster artist, had done work for Alan Sytner before the Cavern Club opened. He was paid a few shillings for producing this poster. It was the going rate, but neither he nor Alan knew what was ahead. This poster was to become world-famous after the Beatles performed at the club about 292 times and went on to become the most successful band in the history of music. The Cavern Club is probably now the most famous club on the planet.

The Cavern Club opened on 16 January 1957 and Tony was commissioned to produce the poster. The opening bill featured the Merseysippi Jazz Band, the Wall City Jazz Men, Ralph Watmough Jazz Band and the Coney Island Skiffle Group, and was to be headlined by an act fronted by a drummer known as the Earl of Wharncliffe. On the night, however, the Earl failed to show up. The Cavern was originally intended to be a jazz and blues venue until the emergence of rock 'n' roll.

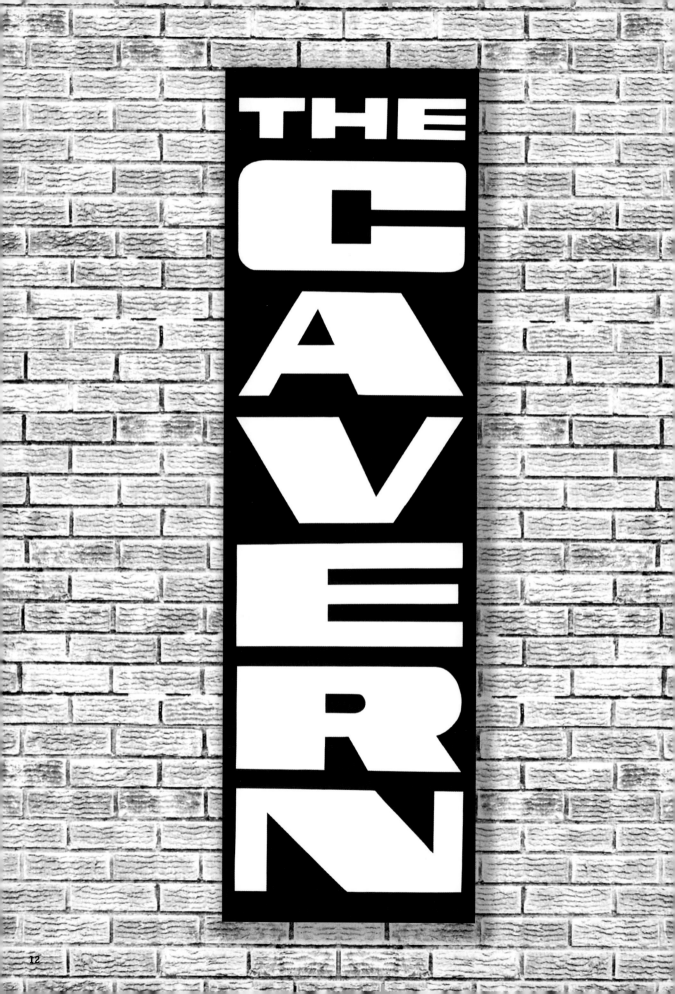

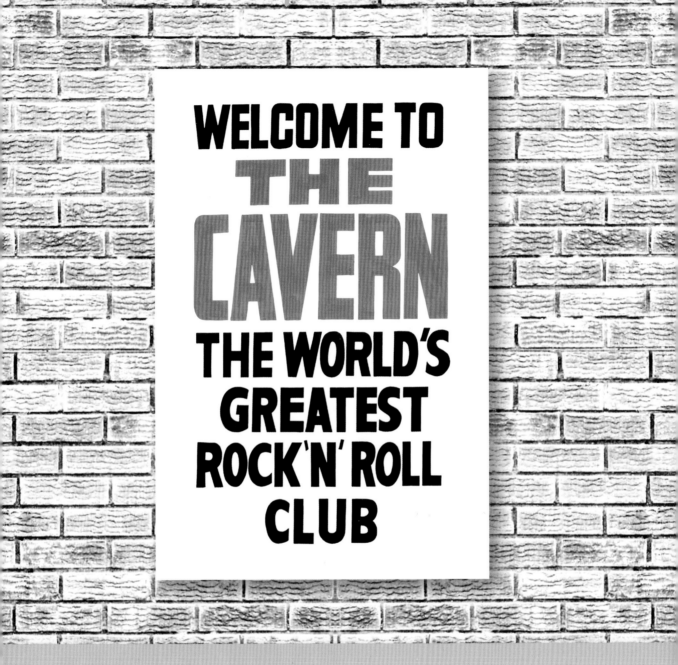

Cavern Club, Liverpool

Early 1960s

The Cavern Club is known as the 'the most famous club in the world' and one of the main characteristics of its identity is the posters produced by Tony Booth that used to be pasted all over the club's walls. Tony was responsible for producing the very first logo for the Cavern.

The most recognisable of the posters is the vertical 'The Cavern' banner. This is iconic to the club's history as it was used as the entrance sign for many years.

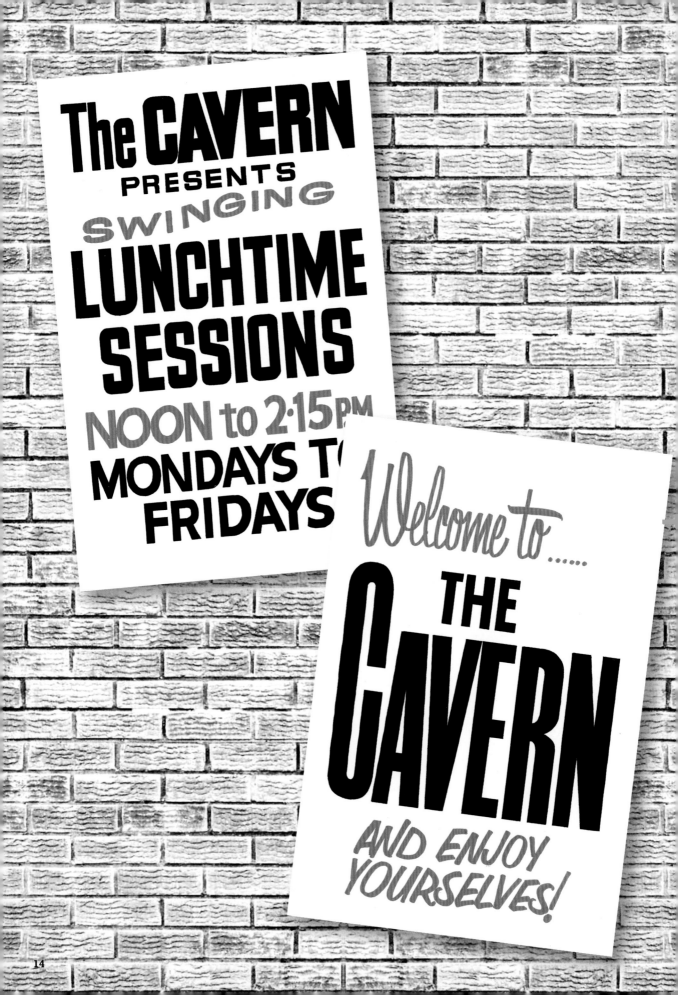

The CAVERN
PRESENTS
SWINGING
LUNCHTIME
SESSIONS
NOON to 2·15 PM
MONDAYS TO
FRIDAYS

Welcome to......
THE
CAVERN
AND ENJOY
YOURSELVES!

THIS IS
WHERE IT ALL
BEGAN !
THE
Cavern

THE
BEATLES
PLAYED
HERE
292
TIMES

Cavern Club, Liverpool
Early 1960s

This is one of the many posters that were usually pasted up at the entrance to the Cavern Club or just inside. Their purpose was to allow members and guests to see what time their favourite groups were playing.

This hand-painted poster is one of the very few Tony Booth originals that still exist after more than fifty years and was sold recently by Christie's of London to an American collector for £27,500.

 THIS COMING
FRIDAY
LUNCHTIME

Special Double Bill
ON STAGE

12·20 P.M.
THE BEATLES

1·00 P.M.
PETE MACLAINE
& THE DAKOTAS

1·40 P.M.
THE BEATLES

 Come Along Early !

Cavern Club, Liverpool
Early 1960s

This poster could be seen on the wall of the Cavern Club cloakroom, where Cilla Black famously worked. She would hand out numbered cloakroom tickets to visitors, who would leave their coats and other belongings with her.

It wasn't long, however, before the Beatles invited her up on the stage to sing with them; it was on this stage that Brian Epstein heard her for the first time. He soon had her name on a contract and very soon she became a chart-topping singer.

ITV produced an award-winning three-part drama series called *Cilla*, starring Sheridan Smith, based on her early life. ITV approached Tony and commissioned him to hand paint the posters for the drama in exactly the same style as back then.

WELCOME
TO
THE CAVERN

AND REMEMBER PLEASE......
DON'T LEAVE ANY OF YOUR
BELONGINGS (Coats, Handbags etc)
THE MANAGEMENT CANNOT ACCEPT
RESPONSIBILITY FOR LOSS OR
DAMAGE - BUT ITEMS CAN BE
KEPT IN THE CLOAKROOM
DURING YOUR VISIT TO THE CLUB

Cavern Club, Liverpool
Early 1960s

This is an example of the information posters that were pasted all over the walls inside Cavern Club to let people know about upcoming events. Given the noise in the club, it was the only way that information could be passed around.

Cavern Club, Liverpool
Early 1960s

This iconic Cavern Club poster was one of the first of many hand-painted posters by Tony Booth to be pasted up on the outside wall of the club. It was also one of the longest to stay up; once they had been stuck up, though it was with nothing more than flour and water, they had incredible staying power!

HURRY! HURRY! HURRY! Get your tickets <u>now</u> for the

★ALL NiTE **BEAT BOAT**

THIS COMING SUNDAY!

6 EXCITING HOURS! 8 TERRIFIC GROUPS!

Get your tickets **NOW** from the **CAVERN!** DON'T DELAY AVOID DISSAPOINTMENT!

←THIS IS **THE CAVERN !**

THE *International* BEAT MUSIC CENTRE

**10 MATHEW STREET
LIVERPOOL**

THE BIRTHPLACE of THE BEATLES

Cavern Club, Liverpool
Early 1960s

This was a 'quad'-size (40in by 30in) landscape poster that was pasted onto the wall above the stairs as you went down into the Cavern Club.

It was designed to greet people and provide information about regular club performances.

WELCOME TO THE CAVERN CLUB

EVENING SESSIONS 7·30 TO 11·15 ON TUESDAYS · WEDNESDAYS FRIDAYS · SATURDAYS & SUNDAYS

FIVE LUNCHTIME SESSIONS 12 NOON TO 2 15PM MONDAYS TO FRIDAYS

NEW MEMBERS WELCOME · JOIN NOW

NOTE : NO ADMISSIONS OR RE·ADMISSIONS BY PASS OUT AFTER 9·30

Liverpool Stadium, Liverpool
Tuesday 3 May 1960

The Beatles never made a single appearance at Liverpool Stadium; however, they were in attendance for this event organised by Allan Williams, then their manager, on 3 May 1960. Eddie Cochran was originally booked to play this event, but a few weeks before he sadly passed away when he was involved in a car crash.

LIVERPOOL STADIUM
TUESDAY MAY 3RD
JACARANDA ENTERPRISES PRESENT...

"The greatest beat show ever to be staged in Britain"

ONE NIGHT ONLY... AMERICA'S GREAT.....

Gene VINCENT

DAVY JONES *Latest U.S.A. Sensation*

ITALY'S FABULOUS **NERO** and his **GLADIATORS**

Britains Newest Stars....

LANCE **FORTUNE** * DEAN **WEBB** * *THE* **VISCOUNTS**

JULIAN 'X' * *COLIN GREEN & THE BEAT BOYS* * Peter **WYNNE**

LIVERPOOL'S OWN **Cass & his Cassanovas** · Mal Perry

Rory Storm & his Hurricanes

Jerry & The Pacemakers

(BILLY RAYMOND COMPERE)

3 HOURS OF BIG BIG BEAT Starting at 8·0 p.m.

Tickets **10/· 7/6 5/·**

Available from... STADIUM · LEWIS'S RUSHWORTH'S · CRANE'S · 'TOP HAT' RECORD BAR, Dale St. FRANK HESSY'S · BEAVER RADIO JACARANDA COFFEE BAR, Slater St.

Lathom Hall, Liverpool
Saturday 14 May 1960

The Beatles performed here as the Silver Beats for this one off occasion. The event was organised Brian Kelly of Beekay Promotions and included other fine acts like King Size Taylor and the Dominoes, The Deltones, and Cliff Roberts and the Rockers.

Jacaranda Coffee Club, Liverpool
Monday 30 May 1960

This event featured the very first appearance for the Beatles at the Jacaranda Coffee Club. They were known at the time as the Silver Beatles (here spelt 'Beetles').

The Jacaranda Coffee Club was owned by Allan Williams. The venue is still standing today, having had many different owners and managers over the years. It was originally a coffee bar and was one of John Lennon's favourite places to hang out.

Jacaranda COFFEE CLUB

23 SLATER STREET • LIVERPOOL

Introducing

The FIRST EVER APPEARANCE!

of

The Silver Beetles

MONDAY 30th. MAY 1960

Starts 7·30 PM

Admission 2'6

PAY AT THE DOOR

| TUESDAY 31st MAY | ★ | Royal Caribbean Steel Band |

Neston Institute, Wirral
Thursday 2 June 1960

Promoted by Les Dodd of Paramount Enterprises, this was the first of his six Thursday evening events at the Neston Institute. On this occasion he allowed rock 'n' roll to take place for the first time at one of his venues. Previously, he had only allowed traditional ballroom dancing at his events. He had no idea of the success that band would go on to achieve.

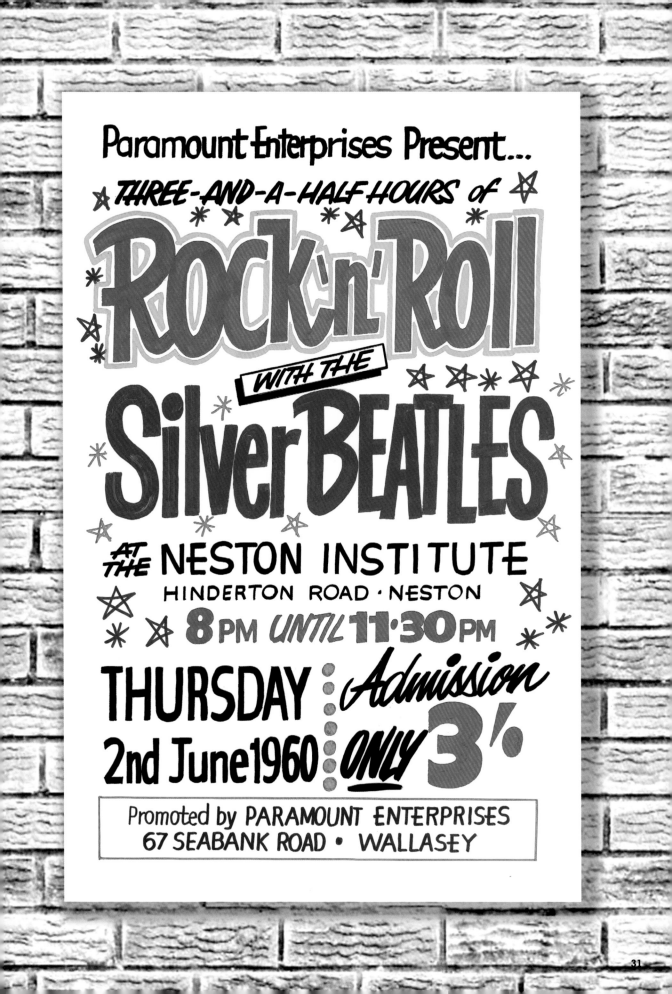

Grosvenor Ballroom, Wallasey
Saturday 4 June 1960

Les Dodd next brought The Silver Beatles to the Grosvenor Ballroom. This venue was notorious for the fights that used to break out in the crowds during Saturday night events. The 'Big Beat Night' slogan prompted the nickname 'Big Fight Night' among locals.

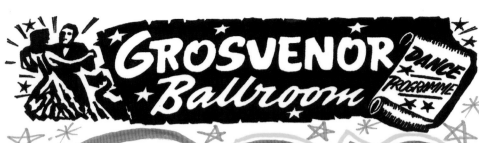

GROSVENOR Ballroom DANCE PROGRAMME

LES DODD Presents

BIG BEAT

Featuring **The Fabulous**

Silver Beatles

SATURDAY 4th June

8pm - 11·45pm Admission — 3!

Grosvenor Ballroom, Wallasey
Monday 6 June 1960

Two days after their first appearance at the Grosvenor Ballroom, The Silver Beatles returned for a 'Whitsun Bank Holiday Monday Special', once again organised by promoter Les Dodd.

Local group Gerry and the Pacemakers performed on the bill and this was the first of numerous occasions that the two bands would play together.

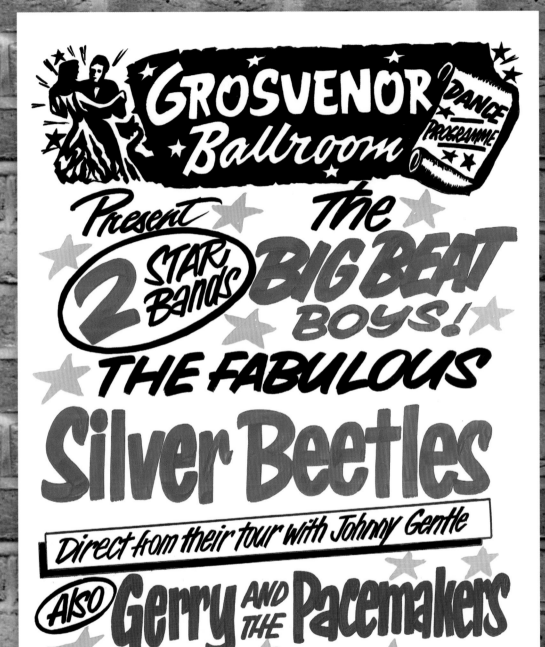

Grosvenor Ballroom, Wallasey
Saturday 11 June 1960

This event at the Grosvenor Ball on 11 June 1960 comes with its own unique story. Tommy Moore was the drummer at the time, but he had become fed up with not making any money, and he didn't turn up at the gig. The Beatles did not want to let the audience down and made a plea to see if there was anyone present in the venue who was able to stand in for the night. Ronnie, a local gangster, responded to the request and took to the stage with them despite not knowing how to really play the drums. It was a disaster, but Allan Williams managed to talk him down.

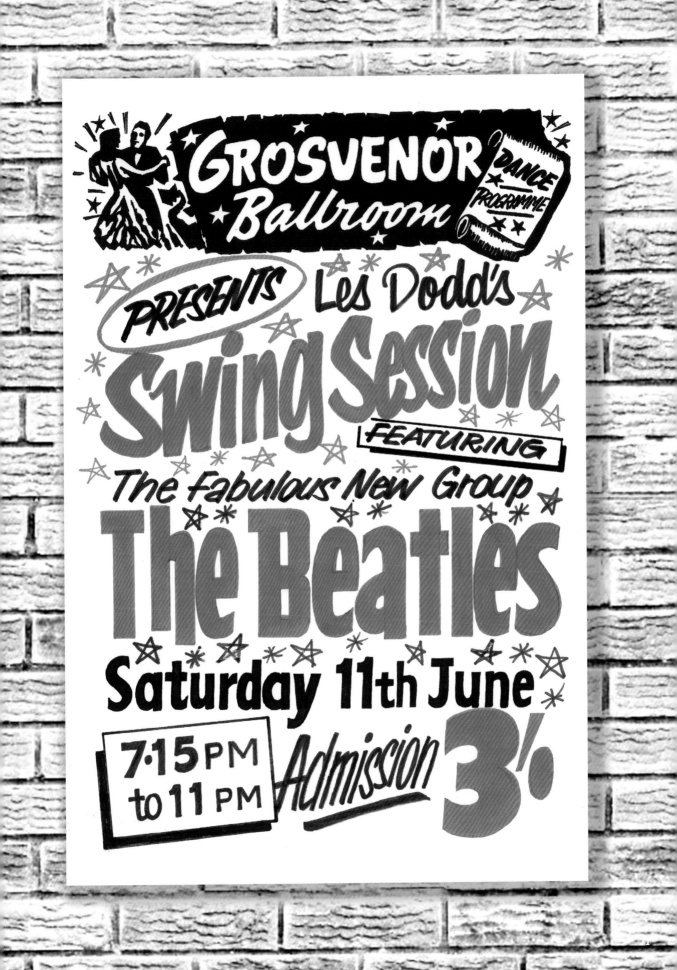

The Neston Institute, Wirral
Thursday 16 June 1960

This was the second of the Silver Beatles' six consecutive Thursday night appearances at the Institute in Neston booked by Les Dodd of Paramount Enterprises.

Les Dodd was not a big fan of rock 'n' roll but he was a shrewd businessman. He saw the money-making potential of running rock 'n' roll gigs even before the Beatles achieved stardom.

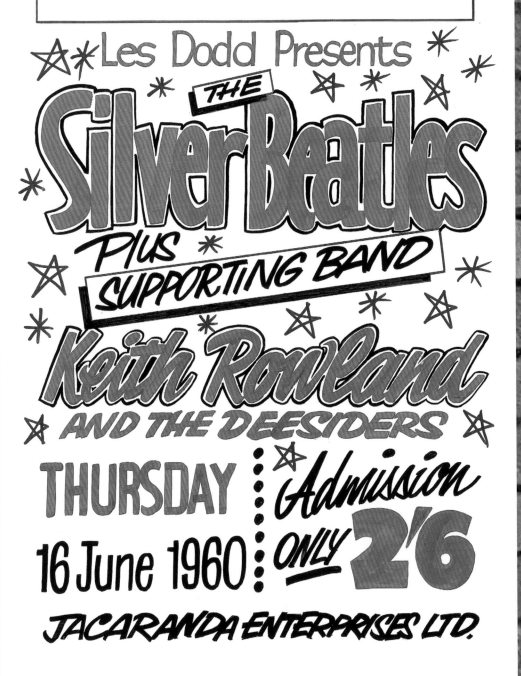

THE INSTITUTE
Hinderton Road · Neston

Les Dodd Presents

THE Silver Beatles

PLUS SUPPORTING BAND

Keith Rowland
AND THE DEESIDERS

THURSDAY
16 June 1960

Admission
ONLY 2'6

JACARANDA ENTERPRISES LTD.

Jacaranda Coffee CLub, Liverpool
Monday 15 August 1960

This was the Silver Beatles' last appearance in Liverpool prior to their departure to Hamburg on 17 August. This tour was initially organised by the Jacaranda's owner, Allan Williams.

Jacaranda COFFEE CLUB

SLATER STREET • LIVERPOOL

The Silver BEETLES

LAST APPEARANCE IN LIVERPOOL – BEFORE THEIR TOUR OF HAMBURG!

MONDAY 15th Aug. 1960

Admission 2/6

PAY AT THE DOOR

BE EARLY – AND GIVE THE BOYS A FAMOUS LIVERPOOL SEND OFF!

Kaiserkeller, Hamburg

Tuesday 4 November 1960

From Tuesday 4 October to Wednesday 30 November 1960, the Beatles made a total of fifty-eight appearances at the Kaiserkeller in Hamburg.

This poster was mailed out to Germany by Tony Booth. Unusually, the club thought the standard poster size, double crown (20in by 30in), was not big enough and they had it enlarged when it arrived.

KAISERKELLER
Tanzpalast der Jugend =
HAMBURG - ST. PAULI
FESTIVAL DER ROCK'n ROLL FANS

IM MONAT OCTOBER - NOVEMBER - DEZEMBER

Präsentiert Bruno Koschmider

ORIGINAL

Rock'n Roll

BANDS

Rory Storm

AND HIS

HVRICAN

und

The Beatles

ENGLAND - LIVERPOOL

43

Casbah Coffee Bar, Liverpool
Saturday 17 December 1960

This was the Beatles' first appearance on Merseyside after their return from Hamburg. It was a packed house, and they were greeted with hand-produced banners reading 'Return of the Fabulous Beatles', which had been made by the owners of the venue. They performed here many times, and it was here they recruited Pete Best as their drummer. His mum, Mona, ran the bar.

THE Casbah COFFEE BAR

8 HAYMANS GREEN · WEST DERBY
LIVERPOOL

DIRECT FROM HAMBURG

THE RETURN OF THE FABULOUS

BEATLES

Saturday 17th DEC. 1960

2/6
PAY AT THE DOOR

Litherland Town Hall, Liverpool
Tuesday 27 December 1960

This was the very first time the Beatles appeared at Litherland Town Hall. They later went on to perform here on a total of twenty occasions. Although the poster is headlined 'Direct from Hamburg', this was actually their third performance since returning from Germany.

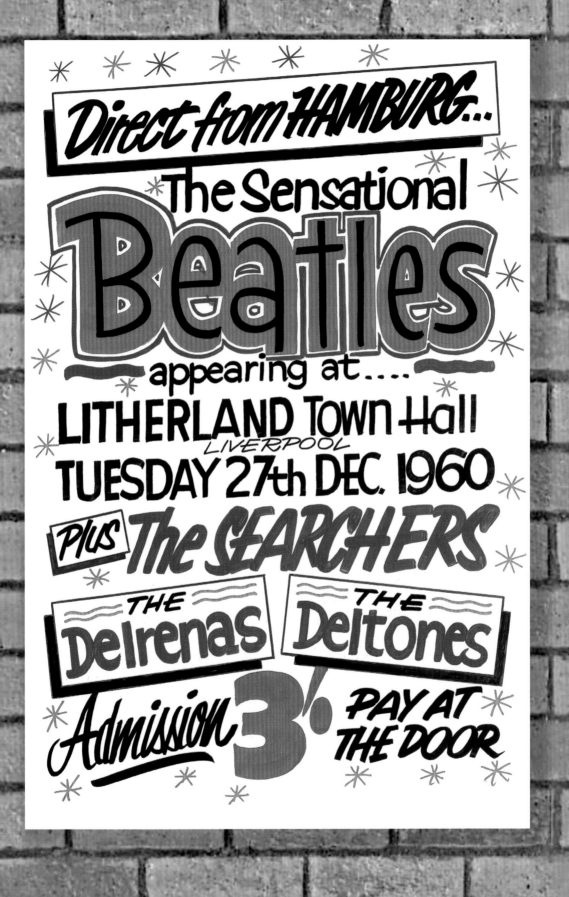

Hambleton Hall, Huyton
Wednesday 25 January 1961

The Beatles made fifteen appearances at Hambleton Hall in 1961 and a final one on Saturday 13 January 1962.

It was at this venue that local promoter Sam Leach saw the Beatles for the first time and began booking them on a regular basis at numerous venues.

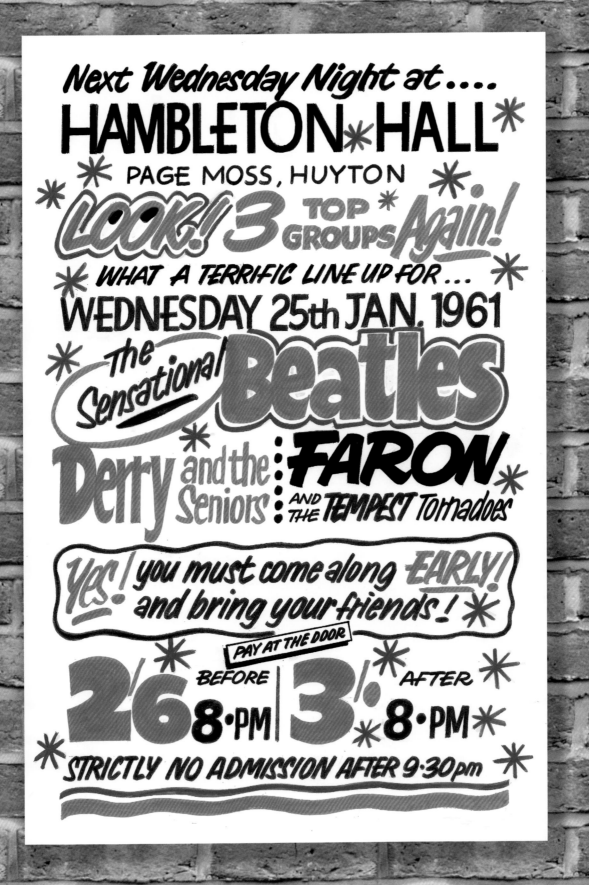

Prescot Parish Rooms, Knowsley
Friday 3 February 1961

The Remo Four – here billed as the 'The Remo Quartet' – appeared on the same bill as the Beatles on many occasions. But for this event, at The Prescot Parish Rooms, they were top of the bill. Brian Epstein went on to invite The Remo Four to be Billy J. Kramer's backing group after this event. They rejected his offer.

Cassanova Club, Liverpool
Tuesday 14 February 1961

The Cassanova Club first started out above the Temple Bar and Restaurant in Dale Street, Liverpool City Centre. Promoter Sam Leach moved the club to bigger premises, above Sampson & Barlow's restaurant and opposite the Odeon cinema, in London Road, Liverpool.

The Beatles played here on seven occasions during February and March 1961. This poster bills the Beatles as the originators of 'the Atom Beat', a new foot-stamping dance craze that caught on with fans – if only for a very short period.

At the "CASSANOVA CLUB"

SAMPSON AND BARLOW'S FABULOUS
NEW BALLROOM
LONDON ROAD OPPOSITE ODEON Cinema

Valentine's Night
Rock Ball

TUESDAY
14th. FEB
7·30/midnight

4 Rompin Stompin Bands!

STARRING THE ORIGINATORS OF 'THE ATOM BEAT' The Sensational Beatles

ROCKIN THE SOUND WAVES THE CASSANOVA BIG THREE

RORY STORM and the HURRICANES

and Introducing MARK PETERS and the CYCLONES

LICENSED BAR AND BUFFET UNTIL **11·0 p.m.**

TICKETS **4'6** (INCLUDING REFRESHMENTS) ON SALE AT
Rushworth's • Lewis's • Cranes

St John's Hall, Tuebrook
Friday 17 February 1961

These two posters are for the same event. The Beatles made eleven appearances at John's Hall in Tuebrook, including this one on Friday 17 February 1961. Their performance fee for the evening was £20.

The gigs at this venue were mostly promoted by Mona Best, who at that time was acting as the unofficial manager of the band.

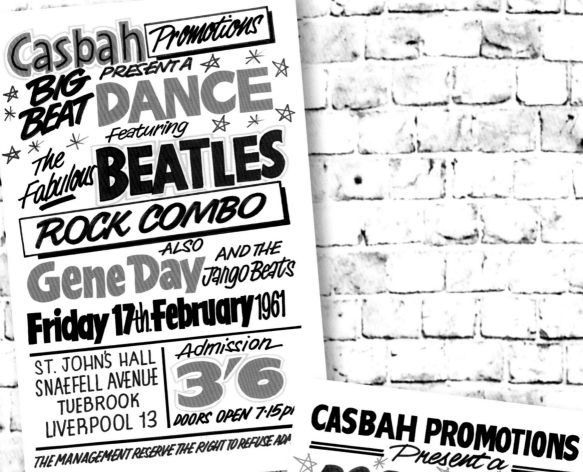

Grosvenor Ballroom, Wallasey
Friday 24 February 1961

This was the Beatles' first appearance over the River Mersey in 1961. The poster featured two different events. Derry and the Seniors, who also played there on 18 February, were fronted by Derek Wilkie, one of Liverpool's first black singers. Sadly he passed away in 2001.

GROSVENOR Ballroom
DANCE PROGRAMME

SATURDAY 18th FEBRUARY 1961

The North West's OUTSTANDING Professional Group **DERRY AND THE SENIORS**

8 PM to 11·45 pm | *Admission* 3'6

FRIDAY 24th FEBRUARY 1961

Dynamic Attraction **THE BEATLES**

DIRECT FROM THEIR CONTINENTAL TOUR

8 PM to 11·30 PM | *Admission* 3'

The Old Iron Door, Liverpool
Saturday 11 March 1961

This event was arguably Sam Leach's biggest promotion to date, booking the Beatles in a line-up with many other top acts at the time. The show was such a hit that even though The Old Iron Door's cellar only capacity for 1,000 people, over 2,000 fans somehow managed to see the show.

THE LEACH ORGANISATION

Presents

Rock-Around THE CLOCK

THE BIGGEST STAR STUDDED ROCK EVENT EVER HELD IN LIVERPOOL

AN ALL NIGHT ROCK Session

8pm - 8am

AT THE **LIVERPOOL JAZZ SOCIETY**

13 Temple Street – THE OLD IRON DOOR

SATURDAY MARCH 11th

— FEATURING —

GERRY AND THE PACEMAKERS

THE SENSATIONAL **BEATLES**	THE FABULOUS **Remo Four**
Rory Storm AND THE HURRICANES	**King Size Taylor** AND THE DOMINOES

Cavern Club, Liverpool
Saturday 5 August 1961

This event was an all-night session at the Cavern Club, which was still predominately a jazz club. Kenny Ball's Jazzmen were the big attraction. The Beatles and The Remo Four did not play their beat music until after midnight.

The Cavern

MATHEW STREET • LIVERPOOL

Presents a

FABULOUS ✳

All-Night Session

SATURDAY 5th. AUGUST

with The Panama Jazzmen

PLUS... AFTER MIDNIGHT ✳

🔵 Kenny Ball's Jazzmen

🔵 Mike Cotton's Jazzmen

The Beatles : The Remo Four

MV *Royal Iris*, Liverpool
Friday 25 August 1961

This famous River Mersey ferry was built in 1951 and known locally as 'the Fish and Chip Boat'. It hosted numerous dances as it sailed up and down the river.

The Beatles performed four times on the boat and this poster is for their first appearance, which took place on Friday 25 August 1961.

*THE CAVERN PRESENTS

A RIVERBOAT SHUFFLE

FRIDAY. 25TH AUG. 1961.

ABOARD THE

" M.V. ROYAL IRIS "

WITH

MR. ACKER BILK'S

PARAMOUNT JAZZ BAND

And THE BEATLES

BOAT SAILS AT 7.45 P.M.
FROM LIVERPOOL LANDING STAGE
RETURNING AT 11.0 P.M.

Tickets 8'6

Grosvenor Ballroom, Wallasey
Friday 15 September 1961

This was the Beatles' final ever appearance at the Grosvenor Ballroom. They had performed here on fourteen different occasions between June 1960 and September 1961.

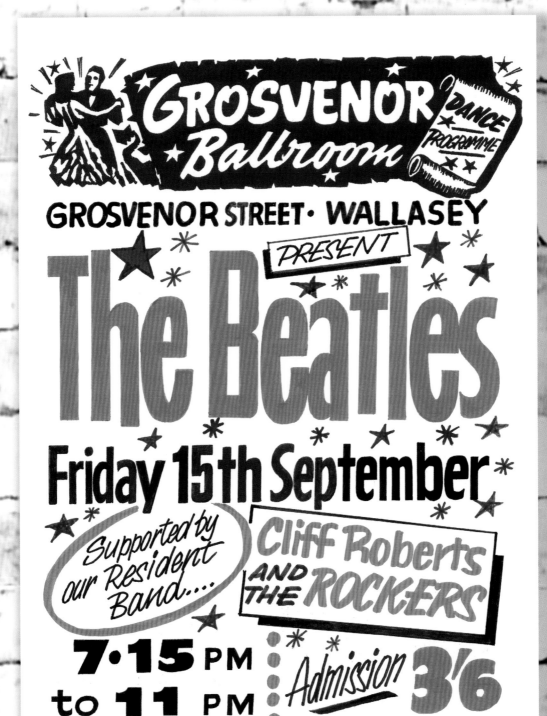

Tower Ballroom, New Brighton
Friday 10 November 1961

This was the very first Operation Big Beat event organised by Sam Leech. It was held at the Tower Ballroom, and 3,000 people packed into the venue to see the Beatles and four other top groups play live music until 1 a.m.

Tower Ballroom, New Brighton

Friday 24 November 1961

The Beatles hit the stage at 11 p.m. for this event, due to a prior performance earlier that day at the Casbah Coffee Club in Liverpool.

Davy Jones, an upcoming singer at the time, joined the Beatles on stage for a couple of songs during their performance.

TOWER BALLROOM NEW BRIGHTON

★ *Sam Leach Promotions* ★

Operation BIG BEAT II

FRIDAY 24th NOVEMBER 1961

Featuring

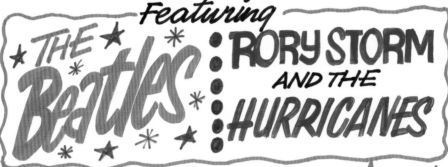

THE Beatles : RORY STORM AND THE HURRICANES

GERRY AND THE Pacemakers | ★ THE Remo Four ★

EARL PRESTON AND THE TEMPEST TORNADOES

FARON AND THE FLAMINGOES : Starts 7·30 PM Tickets 6'

Tower Ballroom, New Brighton
Friday 1 December 1961

The Beatles were booked as the main event for this marathon six-group Big Beat Session at the start of December 1961. This was a very successful night of live music with over 2,000 fans in attendance.

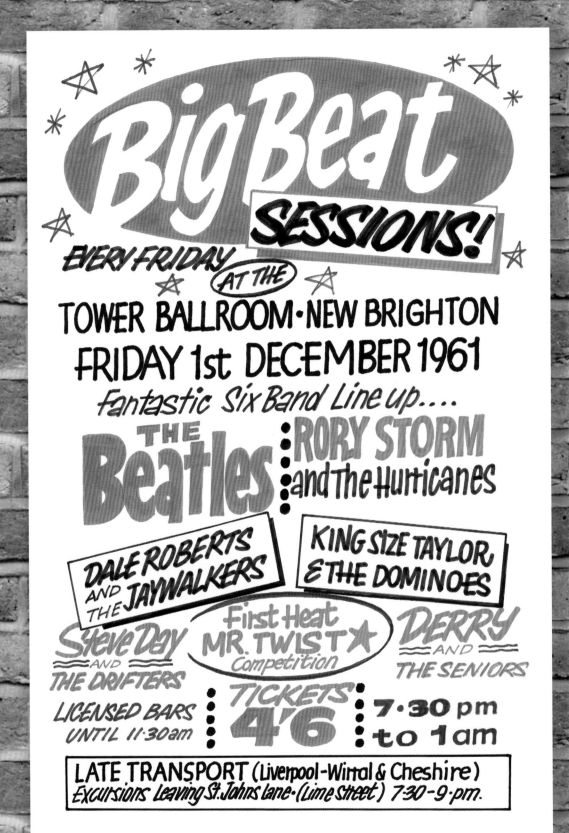

Tower Ballroom, New Brighton
Friday 15 December 1961

This poster promoted a Sam Leach presentation, with four groups providing live music, including the Beatles, that went on until 1 a.m. Cass and the Cassanovas where only added on at the last minute as the special surprise reunion.

TOWER BALLROOM · NEW BRIGHTON

THIS FRIDAY **BIG BEAT** SESSION

15th DECEMBER 1961 · 7·30pm – 1·00am

RORY STORM AND THE HURRICANES

The Beatles

DERRY AND THE SENIORS

Special! SURPRISE Attraction | The BIG THREE & CASS reunite to form... CASS & THE CASSANOVAS

QUARTER FINALS King Twist Competition

LICENSED BARS UNTIL 11·30pm

Tickets 5/-

Buffet

LATE TRANSPORT (Liverpool and Wirral)
Excursions leaving St. John's Lane (Lime Street) 7·30pm – 8·30pm

Tower Ballroom, New Brighton
Saturday 23 and Tuesday 26 December 1961

This 'Pre Xmas Eve Gala' poster was one of the first to include a simple illustration, adding some Christmas atmosphere. The poster featured two different events.

The first night featured three top groups but did not include the Beatles, who were playing at the Cavern Club that evening. The Beatles instead made their appearance on the Boxing Night event.

This is one of only three hand-painted posters on which the group were billed as 'the Beetles'.

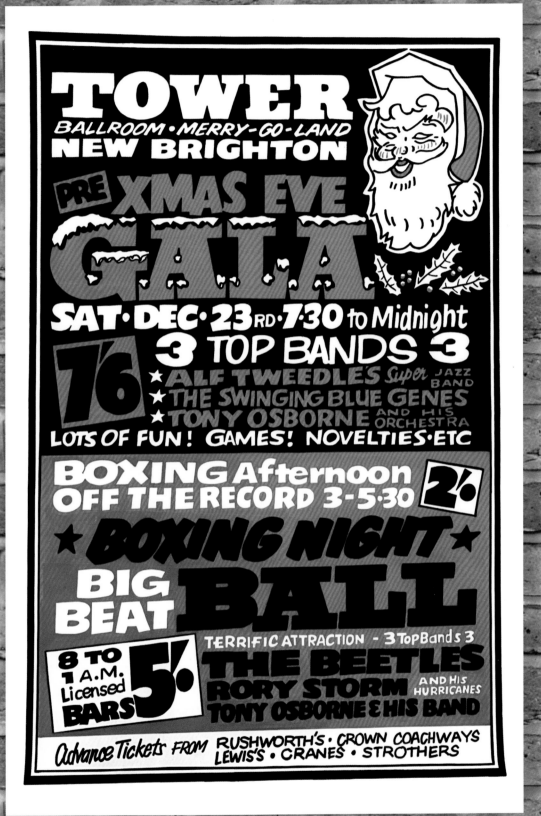

Tower Ballroom, New Brighton
Friday 12 January 1962

The Beatles were now regular headliners at the Tower Ballroom in New Brighton. On this occasion they were not booked as the main event but ended up on stage twice. They played at 9 p.m. and at 11.30 p.m. Their 11.30 p.m. slot was as a replacement for Screaming Lord Sutch and the Savages, who had failed to arrive.

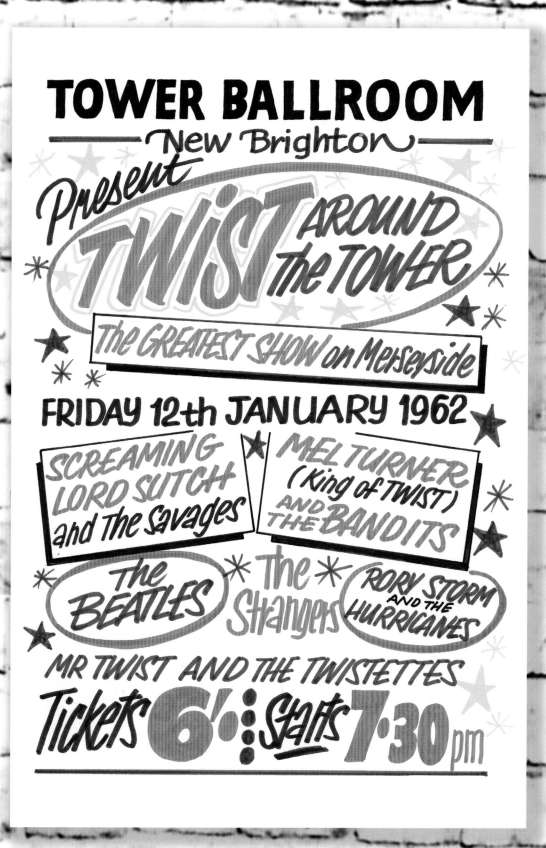

Kingsway Club, Southport
Monday 29 January 1962

This was the second of the Beatles' three consecutive Monday appearances at this Southport venue, just north of Liverpool. To allow under 18s into the venue, the bands had to play upstairs in a ballroom because it was the only area without a fully licensed bar.

Thistle Café, West Kirkby
Thursday 1 February 1962

This event was promoted as the 'Grand Opening' of 'The Beatle Club'. It was also the first time that Brian Epstein took a 10 per cent commission from the Beatles. They were paid £18 for performing.

The event took place in a dance instruction hall above the Thistle Cafe, situated close to West Kirby's beautiful beach and promenade. Steve Day and the Drifters were the support group, and application forms to become a member of The Beatle Club were available for fans.

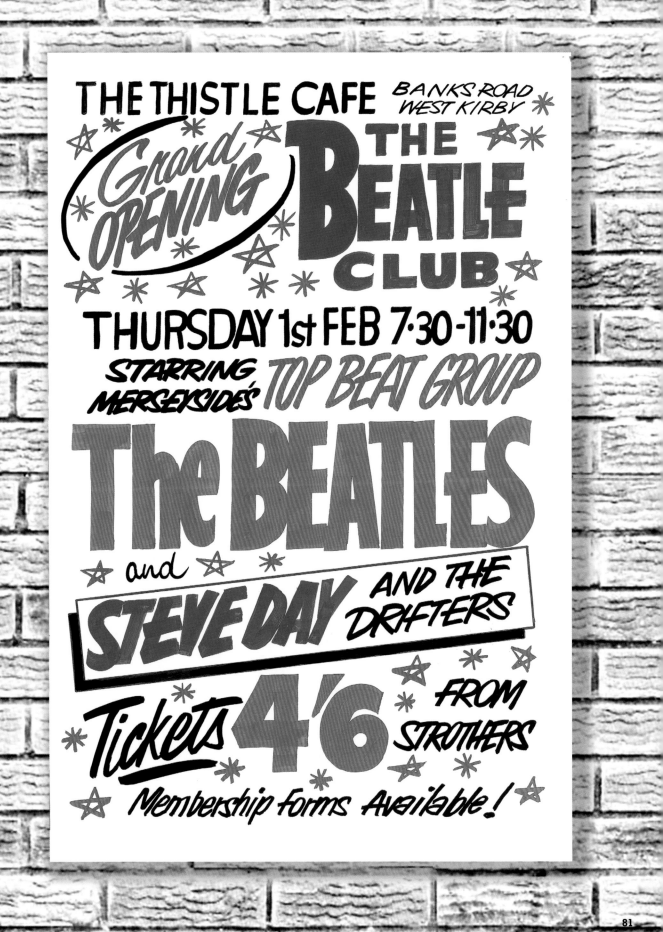

Floral Hall, Southport
Tuesday 20 February 1962

Floral Hall was located on the Victorian promenade in Southport. John Lennon once described the hall as 'a proper theatre with gold curtains'.

To market this show, Brian Epstein asked Tony Booth to bill it as a 'Rock 'n' Trad Spectacular', as it showcased both rock and traditional jazz groups.

Floral Hall • The Promenade • Southport
Presents a
Rock 'n' Trad Spectacular
TUESDAY 20th FEBRUARY 1962
Featuring The Beatles
GERRY AND THE PACEMAKERS
Rory Storm AND The Hurricanes
PLUS
The Chris Hamilton JAZZMEN
Tickets 4'6 AND 5'
FROM THE BOX OFFICE

St Paul's Church Hall, Birkenhead
Saturday 10 March 1962

This was the Beatles' second time at St Paul's. They had first appeared there a month previously, on Saturday 10 February. St Paul's, a Presbyterian church, regularly organised Saturday events for young people in the Birkenhead area.

St. Paul's Presbyterian Church Youth Club
ANNOUNCE A RETURN VISIT OF

Polydor Recording Artists **The Beatles**

**SATURDAY 10th. MARCH 1962
IN THE CHURCH HALL**
NORTH ROAD, TRANMERE, BIRKENHEAD.

ALSO

THE COUNTRY FOUR
WITH **Brian Newman**

Admission by TICKET ONLY! | TICKETS 5/- | 7·30 PM TO 11·30 PM

Knotty Ash Village Hall, Liverpool 14
Saturday 17 March 1962

The Beatles had made seven appearances at this small community hall in 1961, all promoted by Mona Best. This event, on Saturday 17 March the following year, marked their final appearance there. Sam Leach promoted this one, and he billed it as a 'St Patrick's Night Rock Gala'.

The Leach Organisation presents —

St. PATRICK'S NIGHT

"ROCK GALA"

This Saturday 17th March 7·30-11·30 pm.

KNOTTY ASH HALL

(Junction Eaton Rd/ East Prescot Rd)

Starring

* ***THE BEATLES***
* ***RORY STORM &***
THE HURRICANES

Hats * Novelties * Prizes BUFFET

 Admission **5/-**
(at door)

Apollo Roller Rink, Moreton
Monday 26 March 1962

This event is of particular interest as it's the only occasion that poster artist Tony Booth actually used his connections to promote a gig himself, along with his business partner Derek Holmes.

Many Merseybeat bands appeared at the Apollo, including the Beatles on 26 March 1962, but this was their one and only gig there. In the end Tony stuck to what he was good at – producing posters.

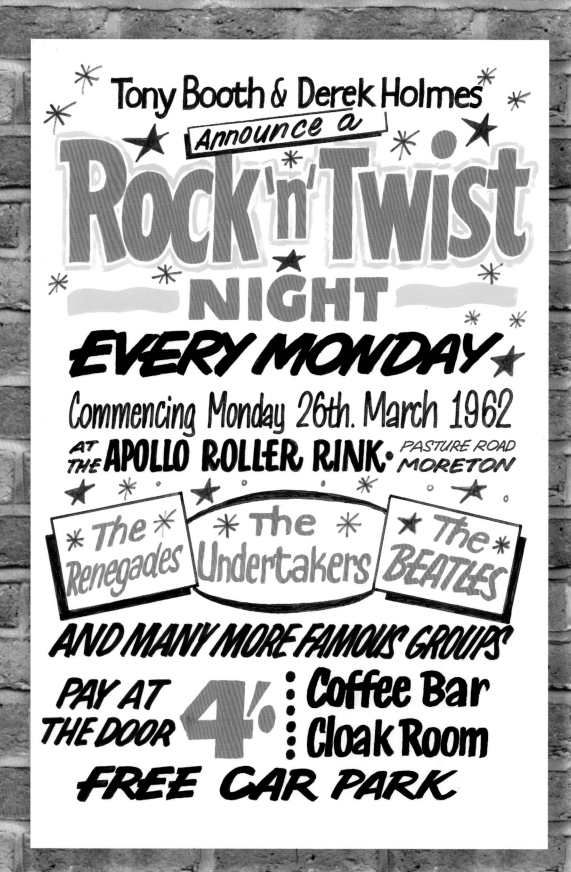

The Odd Spot, Liverpool
Thursday 29 March 1962

This was the Beatles' first appearance at The Odd Spot, which had only opened its doors on 9 December 1961. It was the second time they wore suits on stage; this was to cater for the venue's more upmarket aspirations.

The ODD SPOT CLUB

BOLD STREET · LIVERPOOL
Presents

THE BEATLES
ALSO
The MERSEY BEATS

29th. March 1962

Admission **6/-** PAY AT THE DOOR

NEW MEMBERS Welcome

Cavern Club, Liverpool
Thursday 5 April 1962

This poster was for the sixty-seventh evening appearance by the Beatles at the Cavern Club. A unique feature of this poster is that it displays George's name first. This was a direct request from Brian Epstein to Tony Booth. It was intended to give George a bit of a confidence boost because at the time he felt that he wasn't getting the same attention as the other band members.

Tower Ballroom, New Brighton
Friday 6 April 1962

The Beatles played at the Tower on twenty-seven occasions in total, most of which were promoted by Sam Leach, including this one on Friday 6 April 1962.

This night was known as 'the Beatles Farewell Ball' before they embarked upon another trip to Hamburg.

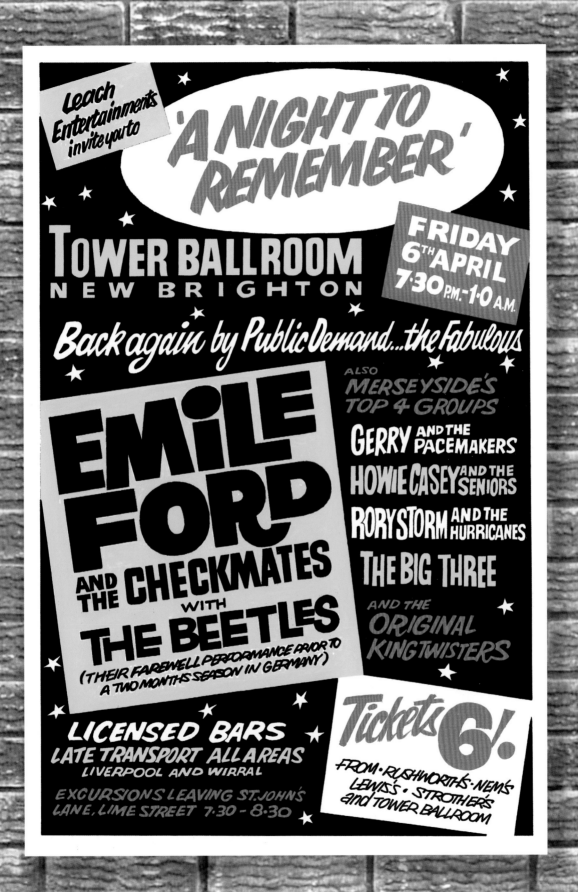

95

Tower Ballroom, New Brighton
Thursday 17 May 1962

This poster promotes a Bob Wooler presentation starring Jerry Lee Lewis, supported by ten upcoming local groups. After the success of this event, Jerry Lee Lewis returned to England in 1963 as part of a European tour. The Beatles were invited to join him on this tour, but Brian Epstein refused, as he no longer considered the Beatles to be a supporting act. Jerry Lee Lewis may have taken offence to this, as he later described the Beatles as having no real talent.

This is the **BIG ONE!**

BOB WOOLER Proudly Presents

* THE FIRST EVER *

"THANK YOUR LUCKY STARS"

* RHYTHM & BLUES STAGE SHOW *

TOWER BALLROOM * NEW BRIGHTON

THURSDAY 17TH MAY 1962 7:30 p.m. TO MIDNIGHT

LATE TRANSPORT · · · · · · · · · LICENSED BARS

STARRING.... DIRECT FROM MEMPHIS, TENNESSEE
* MR. ROCK 'N' ROLL HIMSELF *

Jerry Lee Lewis

NOTE! THIS WILL BE THE ONLY APPEARANCE ON MERSEYSIDE
OF THIS FABULOUS SHOWMAN

PLUS TOP T.V. & RECORDING GROUP

THE ECHOES

BUT WAIT! THAT'S NOT ALL!

THE FOLLOWING GALAXY OF STAR GROUPS HAVE ALSO BEEN EXCLUSIVELY
BOOKED TO APPEAR ON THIS GIGANTIC ROCK SPECTACULAR

THE BIG THREE **THE UNDERTAKERS** **VINCENT EARL & THE ZEROS**

THE PRESSMEN **LEE CASTLE & THE BARONS**

Kingsize Taylor & The Dominoes **THE STRANGERS** **Billy Kramer & The Coasters**

STEVE DAY & THE DRIFTERS **Rip Van Winkle & The Rip it Ups**

HURRY! HURRY! HURRY!
GET YOUR TICKETS <u>NOW</u> PRICE 5/.
FROM:- NEMS · RUSHWORTHS · LEWIS'S · CRANES · JACARANDA COFFEE CLUB
ZODIAC CLUB IN LIVERPOOL * RUSHWORTHS BIRKENHEAD STROTHERS BRANCHES
AND TOWER BALLROOM IN WIRRAL
* ADMISSION: 6/6 AT THE DOOR ON THE NIGHT

THERE'S NEVER BEEN A SHOW LIKE THIS!
READ ALL ABOUT IT IN 'Mersey Beat' - OUT 2ND MAY

Tower Ballroom, New Brighton
Thursday 17 May 1962

This was the second of two posters Tony Booth produced for this gig. It was designed to be an eye-catching crowd-puller. The poster is simple and visually striking, and features only Jerry Lee Lewis, who was big news at the time.

Tower Ballroom, New Brighton
Monday 3 June 1962

The Whit Beat Show at the Tower Ballroom on a bank holiday Monday in 1962 featured six Merseyside bands, the best-known being Rory Storm and the Hurricanes with Ringo Starr on drums shortly before he left the band to join the Beatles. Real name Alan Caldwell, Rory Storm was at the time Liverpool's most energetic and charismatic singer and seemed destined for a successful career. However, although extremely popular in his own city, he failed to break through nationally and sadly died in 1972. His sister Iris was George Harrison's first girlfriend.

Derry Wilkie and the Pressmen, and Ian and the Zodiacs were also hugely popular bands locally who just missed out on the big time.

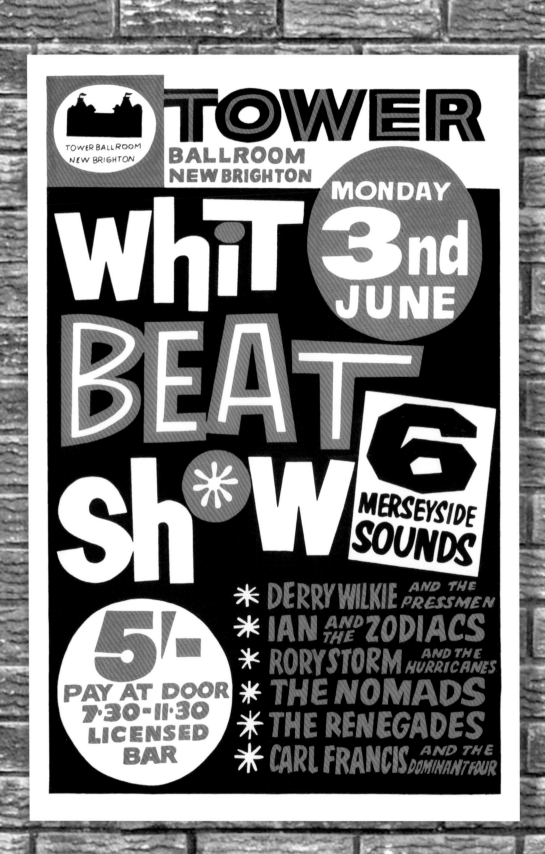

Tower Ballroom, New Brighton
Friday 15 June 1962

Titled 'Rockerama', this event featured five top groups. The main attraction was one of Liverpool's most popular groups at the time, The Mersey Beats.

The Mersey Beats went on to release many hits, including 'It's Love that Really Counts'. Brian Epstein had at one point considered signing up The Mersey Beats but unfortunately changed his mind at the last moment.

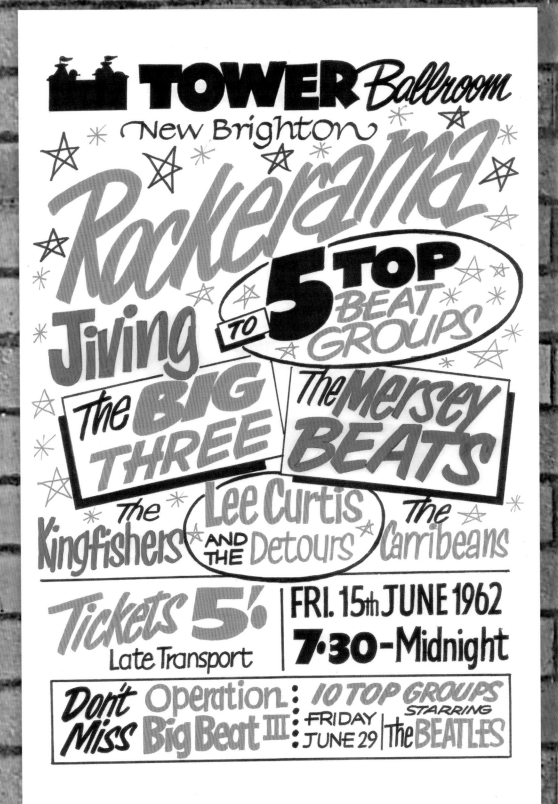

Tower Ballroom, New Brighton
Thursday 21 June 1962

Sam Leach was the promoter for most of the big events at this venue. However, on this night, the promoter for was Brian Epstein. He made the decision to book Bruce Channel onto the bill only five weeks after he had had a top 10 hit with 'Hey, Baby'.

Plaza Ballroom, St Helens

Monday 25 June 1962

This event, hosted at the Plaza Ballroom, was the first by Whetstone Entertainments. Brian Epstein informed the Beatles that Whetstone had sixteen different venues, but failed to mention that most of them were bingo halls!

 The Beatles had already appeared at The Cavern Club earlier that day.

DON'T MISS THIS GREAT EVENT!

BIG MONDAY Re-Opening

PLAZA BALLROOM
DUKE STREET · ST. HELENS

Mon. 25th JUNE 1962

NON-STOP JIVE Session
7·30 to 11·0 pm

HARRY BOSTOCK Presents his

BIG BEAT Bargain Night

Starring The North's No 1. COMBO

Parlaphone RECORDING ARTISTS The Beatles

JUST BACK FROM HAMBURG
FIRST EVER APPEARANCE IN ST. HELENS

Plus The BIG THREE
STARS OF THE JERRY LEE LEWIS ROCKERSCOPE SHOW

Admission 2/6

The show will be PRESENTED by BOB WOOLER DJ & Compere

These Fabulous Attractions con only be seen at The PLAZA

Tower Ballroom, New Brighton
Friday 29 June 1962

Sam Leach continued his successful run of Operation Big Beat events with this third instalment. The Beatles were once again booked as the main event but were joined on the bill by ten other acts. The show included Rock and Twist, and a new dance craze called 'the trance', introduced for the first time in England.

Barnston Women's Institute, Heswall
Saturday 30 June 1962

This was the Beatles' second performance at Barnston Women's Institute. Here the Beatles are billed as 'Parlophone Recording Artists' and part of 'An All Star Show' alongside The Big 3, another very popular act in Merseyside. This venue was hired out by the Heswall Jazz Club for their weekly jazz nights.

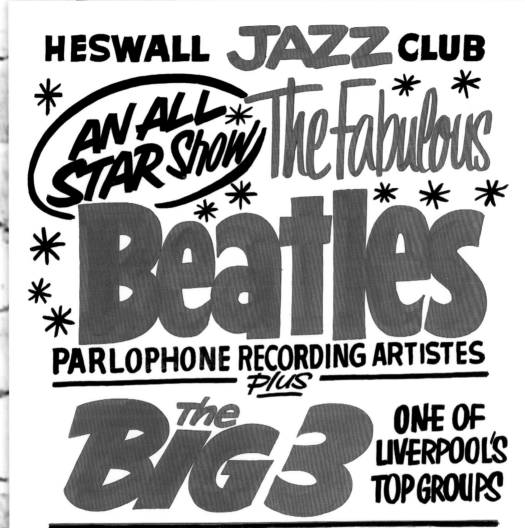

HESWALL JAZZ CLUB

AN ALL STAR SHOW *The Fabulous*

Beatles

PARLOPHONE RECORDING ARTISTES

Plus

The BIG 3

ONE OF LIVERPOOL'S TOP GROUPS

Plus CURRENT TOP 20 RECORDS

BARNSTON WOMEN'S INSTITUTE

BARNSTON ROAD • NEAR HESWALL

SATURDAY 30th. JUNE

7'6 BY TICKET ONLY

DOORS OPEN 7·30

NO ADMISSION AFTER 9·45 p.m.

Regent Dansette Ballroom, Rhyl
Saturday 14 July 1962

This was the Beatles' first performance in Wales, at the Regent Dansette Ballroom in Rhyl, the event organised by promoter Joe Flannery. They were supported by The Strangers.

A plaque designed by Tony Booth has now been placed on the building to commemorate the Beatles' appearance there.

113

Cabaret Club, Liverpool
Wednesday 25 July 1962

The Cabaret Club was a favourite haunt of Brian Epstein and he was responsible for securing this booking for the Beatles. The club catered for an older, more sophisticated clientele than most. This was one of Tony Booth's favourite places, even though he was only in his 20s at the time. The members actually preferred cabaret performers like Liza Rosa – the first Liverpool performer to have a number 1 UK hit with 'How Much is that Doggie in the Window' in 1953. By all accounts, the Beatles' performance did not go down very well, and they were not rebooked.

Interestingly, this poster advertises the incorrect day of the week for this performance – Monday rather than Wednesday.

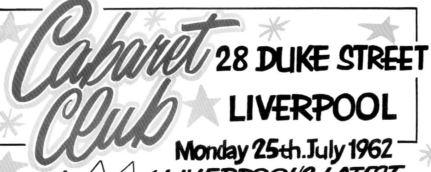

Cabaret Club

28 DUKE STREET
LIVERPOOL

Monday 25th. July 1962

PRESENT

LIVERPOOL'S LATEST
ROCK SENSATION!
FOR ONE NIGHT ONLY!

The BEATLES

WITH DANCING TO
THE ZENITH SIX
Jazz Band

MEMBERS AND GUESTS TICKETS
AVAILABLE FROM THE CLUB

Tickets 5'

SMART ATTIRE
ESSENTIAL

Cambridge Hall, Southport
Thursday 26 July 1962

Organised by Brian Epstein, this event was the only occasion on which the Beatles played at this venue. The main act of the night was Joe Brown, who had recently released the hit single 'Picture of You'. There were several other popular acts on the bill including Gerry and the Pacemakers and The Big Three.

AFTER HEARING

JOE BROWN's

HIT RECORD
"Picture of you"

see him in person
with his 'BRUVVERS'

AT THE
CAMBRIDGE HALL
SOUTHPORT

SUPPORTED BY THE NORTH'S GREATEST SOUND

the sensational 'BEATLES'

PLUS

GERRY
AND THE
PACEMAKERS

THE
BIG THREE

Pete McLaine
AND THE DAKOTAS

the
4 JAYS

26 JULY 1962

Watch local press
for details!

Tower Ballroom, New Brighton
Friday 27 July 1962

These are two iconic posters for the same event. Brian Epstein promoted this event on Friday 27 July 1962. It was the second part of a two-night special featuring Joe Brown and his Bruvvers, with the Beatles as the main supporting group. The first night took place on 26 July at Cambridge Hall, Southport. Gerry and the Pacemakers played at Cambridge Hall but were replaced the following night at the Tower Ballroom by The Statesmen.

At this stage in their career the Beatles hadn't achieved chart success, whereas Joe Brown had reached number 2 with his single 'Picture of You'.

The Four Jays, also on the bill, became The Fourmost and went on to achieve a number of hit singles, including 'Hello Little Girl', which was written by Lennon and McCartney. It reached number 9 in the charts.

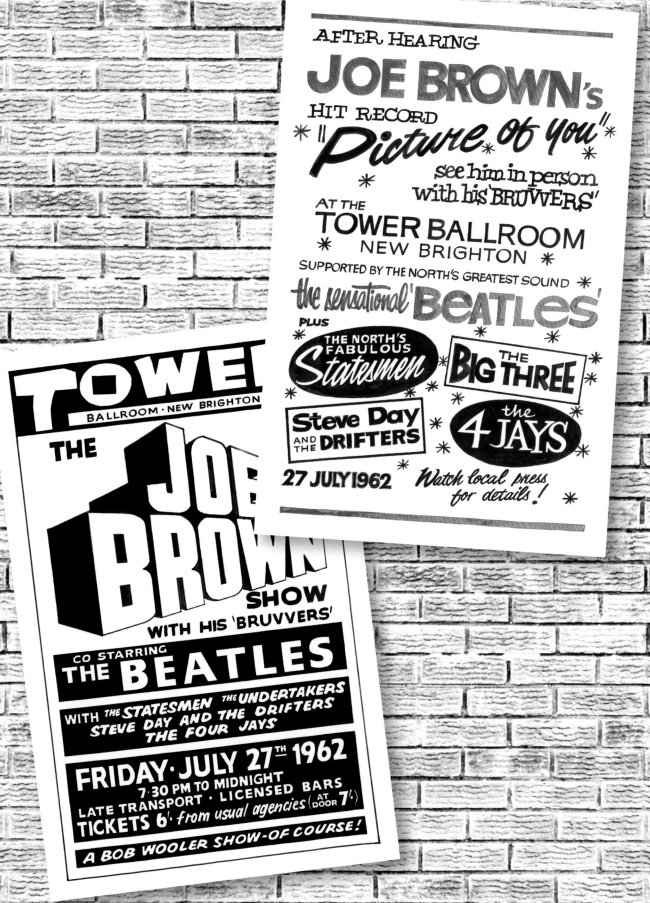

St John's Hall, Bootle
Monday 30 July 1962

Dave Forshaw from Bootle was a promoter who had organised many events in the area. He was the one who branded the hall as 'The Blue Penguin Club'. The hall's resident band were The Mersey Beats, who played there every Monday. Understandably when the Beatles were booked to play on this occasion, The Mersey Beats acted as support on the bill.

The Odd Spot, Liverpool
Saturday 11 August 1962

This was the second and the last appearance of the Beatles at The Odd Spot. Most of the other local bands appeared here. The Mersey Beats, once again supporting, went on to have several chart hits. Their biggest was 'I Think of You', which reached number 5.

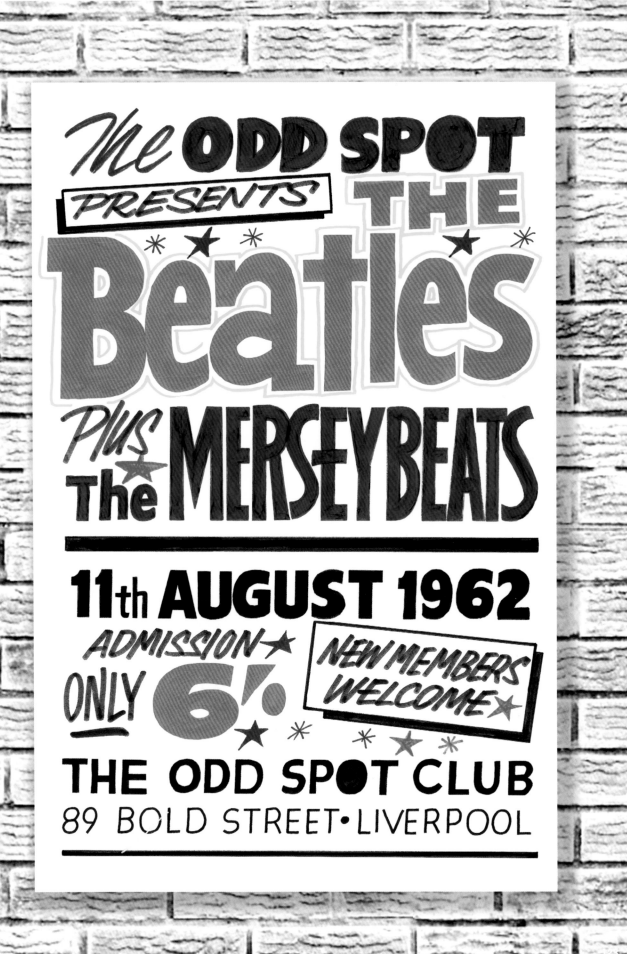

Tower Ballroom, New Brighton
Friday 17 August 1962

This was the Beatles' twentieth appearance at the Tower Ballroom in New Brighton. Pete Best had been sacked by Brian Epstein the previous day, so the group were left without a drummer. Johnny Hutchinson of The Big Three stood in as drummer for them on this evening.

LEACH ENTERTAINMENTS present
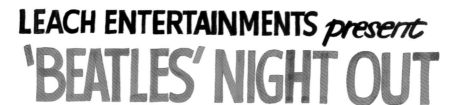
'BEATLES' NIGHT OUT
TOWER BALLROOM • New Brighton
FRIDAY AUG. 17TH 7·30 PM – 1 AM

starring
THE NORTH'S TOP GROUP!
THE BEATLES

SUPPORTED BY

* BILLY KRAMER with the COASTERS
* LEE CURTIS and the ALL STARS
* FARON and the FLAMINGOES

LICENSED BAR APPLIED FOR
LATE TRANSPORT
TICKETS 5/

From:
RUSHWORTHS
NEMS
STROTHERS

Hulme Hall, Port Sunlight
Saturday 18 August 1962

This was the Beatles' second appearance at Hulme Hall in Port Sunlight, this time supported by The Four Jays. This was a significant event because it was Ringo Starr's official debut with the band. He had performed with them prior to this but only in an unofficial capacity.

Cambridge Hall, Southport

Friday 31 August 1962

This event was organised by Brian Epstein. 'Mikes Night' featured Mike Berry as the main attraction and supporting band The Phantoms. The other groups that made up the bill were The Dancers, The Big Three, Billy Kramer and the Coasters, and The Four Jays.

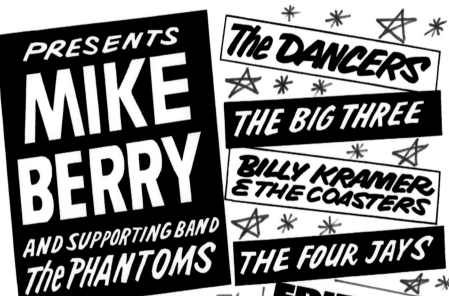

Cambridge Hall
LORD ST. SOUTHPORT
NEM'S ENTERPRISES LTD.
THEATRICAL, CONCERT AND VARIETY AGENCY

MiKES NiGHT

PRESENTS
MIKE BERRY
AND SUPPORTING BAND
The PHANTOMS

The DANCERS

THE BIG THREE

BILLY KRAMER & THE COASTERS

THE FOUR JAYS

ADMISSION IN ADVANCE **6'.** **7'.** AT DOOR
AVAILABLE FROM BOX OFFICE,
THE SOUTHPORT VISITER AND
NEMS ENTERPRISES LTD.
WHITECHAPEL, LIVERPOOL.

FRIDAY 31ST AUGUST 8PM - 11PM

REFRESHMENTS ARE AVAILABLE AT THE
BAR PRIOR TO THE SHOW AND DURING THE INTERVAL

Queens Hall, Widnes
Monday 3, 10 and 17 September 1962

These were the first three of five appearances by the Beatles at this venue. Unfortunately, on the first date, 3 September 1962, they were not well received, due to the recent replacement of Pete Best on the drums by Ringo Starr.

Queens Hall, Widnes
Monday 3 September 1962

The frosty reception at the Queens Hall was made worse by the fact that the newly formed Beatles shared the bill with Rory Storm and the Hurricanes, Ringo Starr's previous group. You could have have cut the atmosphere with a knife that evening.

NEMS ENTERPRISES

QUEENS HALL
WIDNES

'Showdance'

☀ TONIGHT'S ☀
PROGRAMME....

7·45 **GEOFF STACEY**
AND THE WANDERERS

8·55 **THE BEATLES**

10·0 **RORY STORM**
And The Hurricanes

— *Bob Wooler Production*

Rialto Ballroom, Liverpool
Thursday 6 September 1962

A popular Liverpool ballroom, which also included a cinema, the Rialto started hosting beat groups in the late 1950s. This was the first time the Beatles performed at the venue after Sam Leach decided to book them here.

The Village Hall, Irby
Friday 7 September 1962

This was one of only a few gigs played by the Beatles that were a massive flop. Only around 100 people attended, which meant the promoter did not have the money to pay the band their full fee. The Village Hall organised a jumble sale to raise the remaining money owed to the acts.

The Village Hall • Irby
PRESENT A
Dance
FEATURING
The Beatles
AND THE COURTING Group
FRIDAY 7th. SEPT. 1962
Commencing 8•PM to 11•30pm
Tickets 7/6 EACH

YMCA Whestone Lane, Birkenhead
Saturday 8 September 1962

The Beatles performed only once at YMCA Whestone Lane in Birkenhead, on Saturday 8 September 1962. Their appearance was scheduled in between two recording sessions held in Abbey Road, during which they recorded 'Love Me Do'.

Tower Ballroom, New Brighton
Friday 14 September 1962

Promoter Sam Leach continued his series of highly successful Tower Ballroom events, with this 5½-hour-long instalment of Operation Big Beat 5.

The Beatles headlined the six-group line-up and were billed as 'The North's Top Rock Combo'. Rory Storm took second billing on this occasion, with Gerry and the Pacemakers third. Other acts appearing included Billy Kramer and the Coasters, The Four Jays and The Mersey Beats.

LEACH ENTERTAINMENTS PRESENT

OPERATION BiG BEAT-5TH

AT THE

TOWER BALLROOM NEW BRIGHTON
FRI. 14TH. SEPT. 7·30 - 1·0 A.M.

INTRODUCING AN ALL STAR & GROUP LINE UP - STARRING
THE NORTH'S TOP ROCK COMBO - APPEARING AT 10·30 - 1·0 AM

The BEATLES

RORY STORM WITH THE Hurricanes

GERRY AND THE PACEMAKERS | THE 4 JAYS

BILLY KRAMER WITH THE COASTERS | THE MERSEY BEATS

TICKETS 5/-

★ LICENSED BARS (UNTIL 12·15 AM)
LATE TRANSPORT (ALL AREAS (L'POOL) & WIRRAL)
★ COACHES LEAVE ST. JOHN'S LANE / LIME ST. 7·30
FROM -
RUSHWORTHS · NEMS · CRANES · STROTHERS
LEWIS'S · TOP HAT RECORD BAR · TOWER BALLROOM

Barnston Women's Institute, Heswall
Tuesday 25 September 1962

This was the Beatles' third and final appearance at the Heswall Jazz Club at Barnston Women's Institute. Also playing on the same bill were Gerry and the Pacemakers, Gerry was frequently billed as 'Mr Personality', due to his warm and lively stage presence.

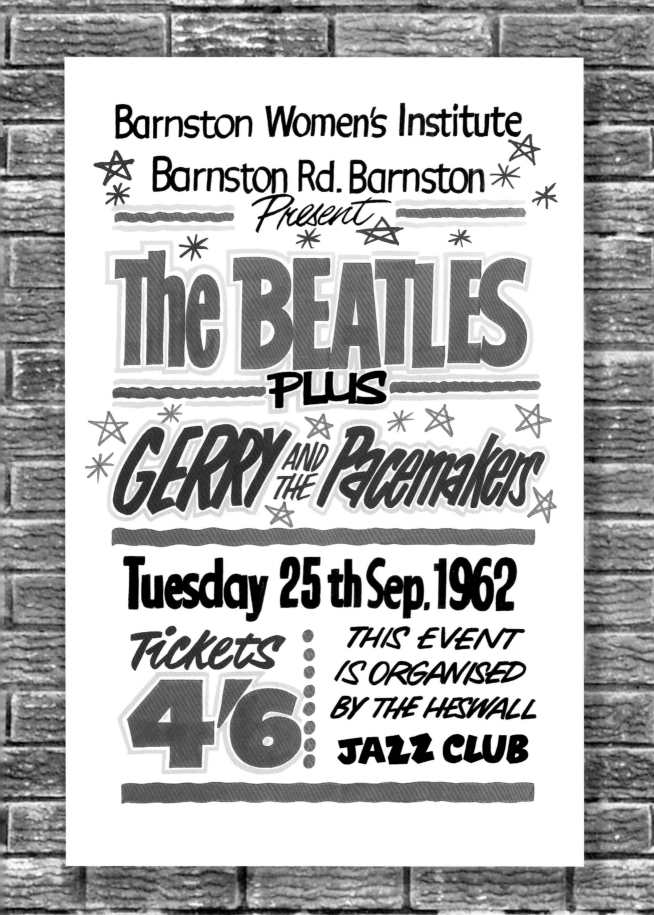

Rialto Ballroom, Liverpool
Thursday 11 October 1962

This was the second of two appearances the Beatles made at the Rialto Ballroom. It was promoted by the Liverpool University Students' Union and featured other acts popular at the time. There was an exhibition of various Merseybeat drawings and photographs by Billy Harry that guests could view upon entering the venue.

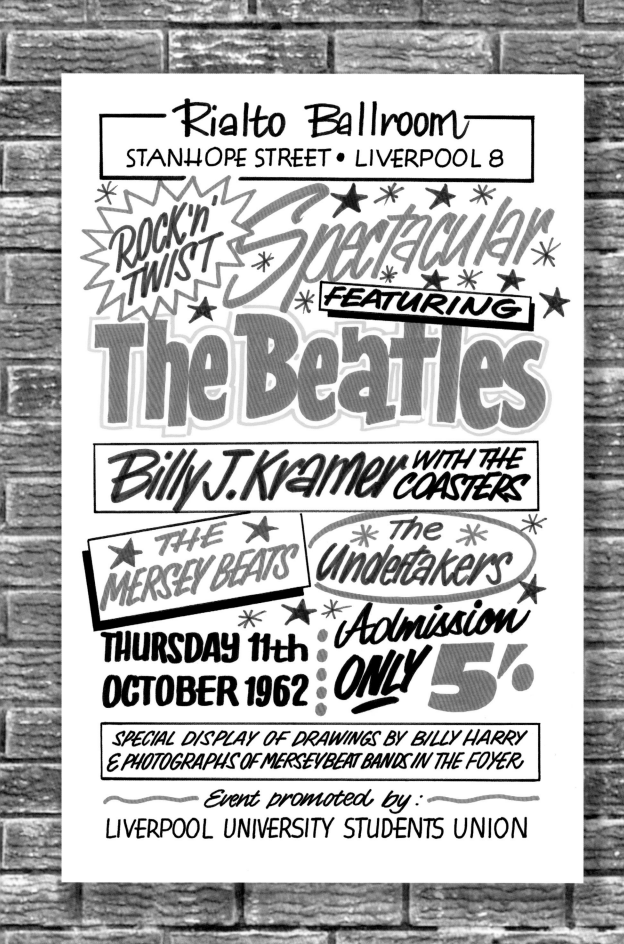

Tower Ballroom, New Brighton
Friday 12 October 1962

America's 'fabulous' Little Richard (*The Fabulous Little Richard* was one of Little Richard's albums) was one of the world's greatest rock 'n' roll performers. He topped the bill in this Brian Epstein production, which lasted over 5 hours and was a huge hit.

The Beatles were billed as the supporting group. Other top Liverpool groups were not even mentioned on the poster. This was all part of Brian's strategy; he thought that having the Beatles billed with Little Richard would give them the boost they needed to get higher up the charts.

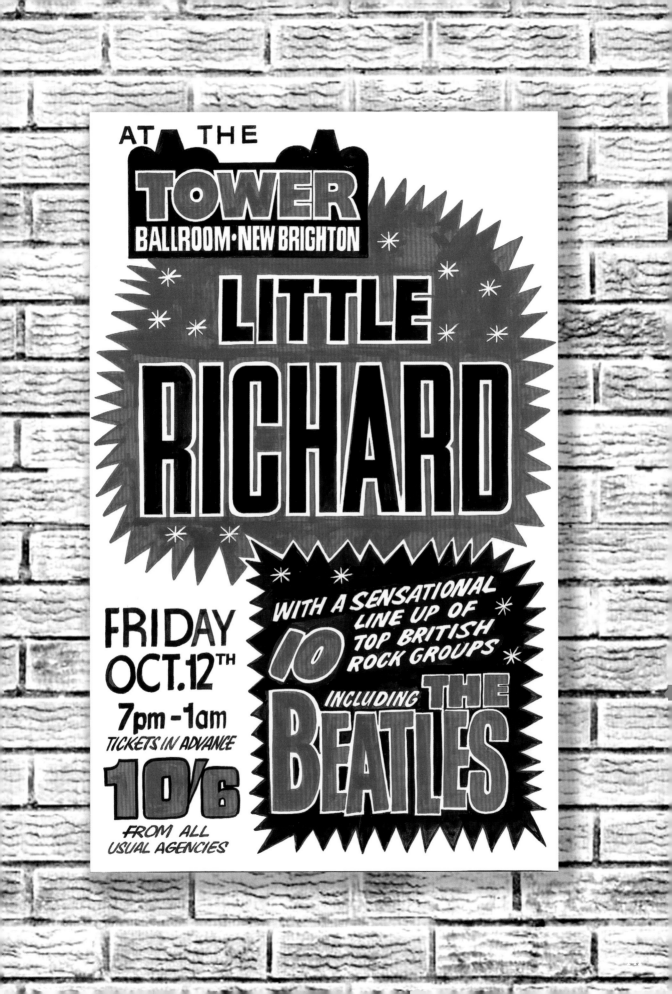

The Public Hall, Preston
Friday 26 October 1962

This was the first of only two appearances made by the Beatles in Preston. Supporting on the night was Mike Berry and his backing group The Outlaws, known for their release of 'Tribute to Buddy Holly', which reached number 26 in the UK single charts.

Cavern Club, Liverpool
November 1962

The Beatles appeared at the Cavern Club seven times during November 1962. This was a standard poster used throughout that month to advertise the regular slots at the club and is an iconic image of that period.

Royal Lido, Prestatyn

Saturday 24 November 1962

This was the Beatles' second ever appearance in Wales, at the Royal Lido in Prestatyn on 24 November 1962. A commemorative plaque designed by Tony Booth has now been installed on the existing building to celebrate the Beatles' appearance there.

ROYAL LIDO · PRESTATYN
North Wale's finest Ballroom
SATURDAY 24th. NOVEMBER
Dancing 8PM - 11·45PM

★ *INTRODUCING* ★ *

TOP MERSEYSIDE RECORDING GROUP
The *Beatles* ★ ★
LATEST RECORDING "LOVE ME DO"

Supported by
JACK ELLIS and the Autocrats

| *Licensed BAR* | *Cash Buffet* |

TICKETS IN ADVANCE 5'-
6'- AT THE DOOR

☆ **LATE TRANSPORT** ☆
TO LOCAL DISTRICTS

La Scala Ballroom, Runcorn
Tuesday 11 December 1962

Brian Epstein promoted this event at La Scala in Runcorn, which was the Beatles' second gig in Runcorn. One week later, they were off again touring in Hamburg.

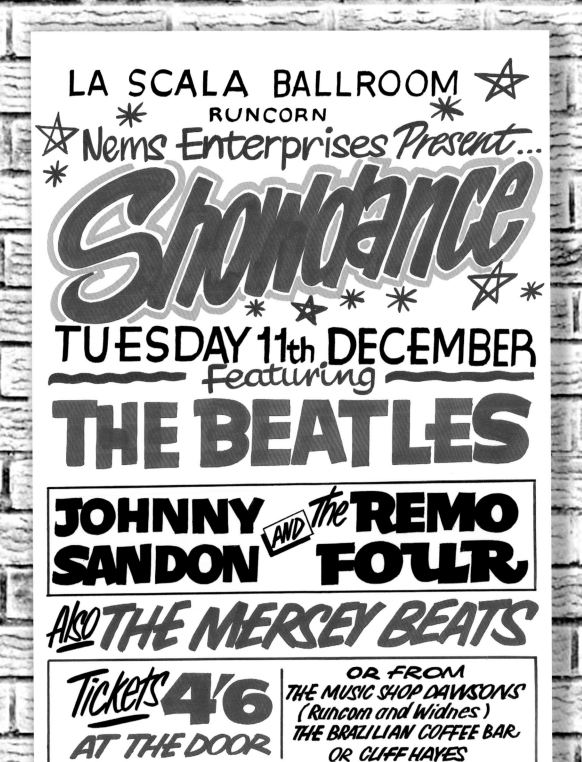

Corn Exchange, Bedford
Thursday 13 December 1962

This poster is for the Beatles' only performance at the Corn Exchange in Bedford. They topped the event, which included Robin Hall and Jimmie Macgregor. The Beatles were a late booking by the promoter because Joe Brown, who had been originally booked to play, withdrew from performing.

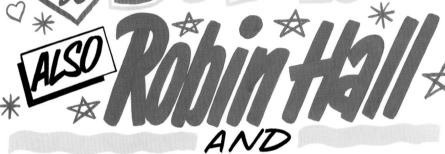

CORN EXCHANGE · BEDFORD
Present
PARLAPHONE RECORDING STARS
The Beatles
LOVE ME DO
ALSO Robin Hall
AND
JIMMY MACGREGOR
WITH SUPPORTING Group

DECEMBER 13th 8-11-30pm
Admission 3/- OWING TO NON-APPEARANCE
OF JOE BROWN

Majestic Ballroom, Birkenhead
Saturday 15 December 1962

On this evening the Beatles performed at the Majestic Ballroom prior to their appearance later on at the 'Mersey Beat Poll Awards'. Of course the Beatles won the poll, so they had to perform for the second time that night at 4 a.m.

Grafton Ballroom, Liverpool
Thursday 10 January 1963

This was the Beatles first gig in Liverpool in 1963 and it was a packed house.

The agreement made between Brian Epstein and promoter Albert Kinder was that the Beatles would be paid £100 to perform. This was agreed almost six months earlier, and by the time the night came around they had two hit singles under their belts and were commanding much higher performance fees. Nonetheless, Brian Epstein honoured the original agreement.

★ The GRAFTON Ballroom ★

THURS. 10ᵀᴴ JAN from 7·30 to 12·30

FIRST 1963 APPEARANCE ON MERSEYSIDE OF

THE Beatles

ALSO

GERRY & THE PACEMAKERS **BILLY ELLIS TRIO** **SONNY WEBB & The CASCADES**

JOHNNY HILTON SHOWBAND

MC THE ONE & ONLY **BOB WOOLER**

TICKETS 7/- ★ IN ADVANCE 6/-

FROM :- *NEMS · LEWIS'S · CRANES RUSHWORTHS · HESSY'S · The GRAFTON*

Co-Operative Hall, Darwen
Friday 25 January 1963

This dance was organised by the local Baptist minister who in May 1962 started inviting local beat bands to play at the church youth club.

Once again the Beatles had been booked many months prior to their performance there, before they had any hit records, so their fee was only £30. Brian Epstein again honoured the original agreement. They played a 45-minute set and were supported by three other bands.

A Dance promoted by The Local Baptist Church Youth Club

FRIDAY NEXT – 25th JANUARY 1963

BAPTIST YOUTH CLUB – Invite you to

The Greatist Teenage **Dance**

Featuring

THE BEATLES

Supported by

The ELECTRONES

The Mike Taylor Combo

The **MUSTANGS** with **RICKY DAY**

IN THE CO-OPERATIVE HALL
MARKET STREET • DARWEN, LANCS

| TICKETS 6/- | Non-stop Dancing 7·30-11·30pm | BUFFET | Admission By Ticket ONLY |

Locarno Ballroom, Liverpool
Thursday 14 February 1963

The Locarno first opened in 1905 but was named the Olympia for many of its earlier years. The Locarno was the premier Mecca ballroom in Liverpool.

The Beatles appeared here just the once, for this special Valentine's night promotion on Thursday 14 February 1963.

Locarno Ballroom, Liverpool
Thursday 14 February 1963

This artwork was an additional flyer created to promote the Beatles' performance on Valentine's Day at the Locarno Ballroom. Note the intriguing offer of 'free gifts' for the first 500 ladies.

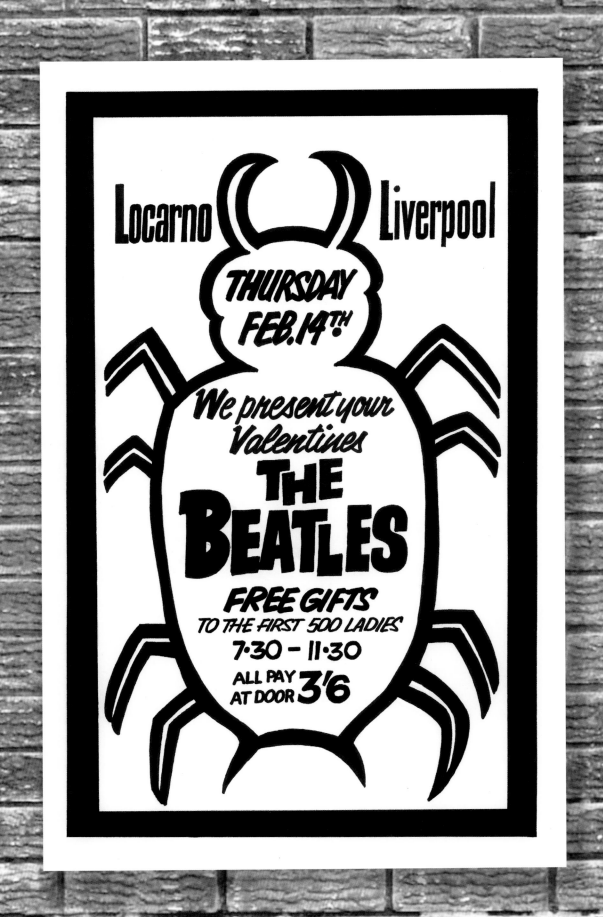

The Beatles Logo Banner
Early 1960s

Tony Booth was commissioned by Brian Epstein to produce a new logo for the Beatles that could be used as a backdrop banner to be displayed when they were performing on stage. Despite this logo becoming iconic, Tony was initially only paid the standard poster rate for producing it.

Cavern Club, Liverpool
Tuesday 19 February 1963

This was a one-off poster placed inside the Cavern Club. When this performance came around at the Cavern Club on 19 February 1963, the Beatles' fame had had a dramatic upturn. Queues to get in would start several days prior to the event.

The Beatles played regularly at the Cavern, but this night was in particular high demand as they hadn't performed there for the previous two weeks.

Odeon Cinema, Southport
Friday 1 March 1963

The Beatles' appeared at the Odeon in Southport on Friday 1 March 1963 as part of their first UK tour, which ran from Saturday 2 February to Sunday 3 March. Also appearing was Helen Shapiro. She was just 16 years old but had already released hits such as 'Walking Back to Happiness' and 'You Don't Know'.

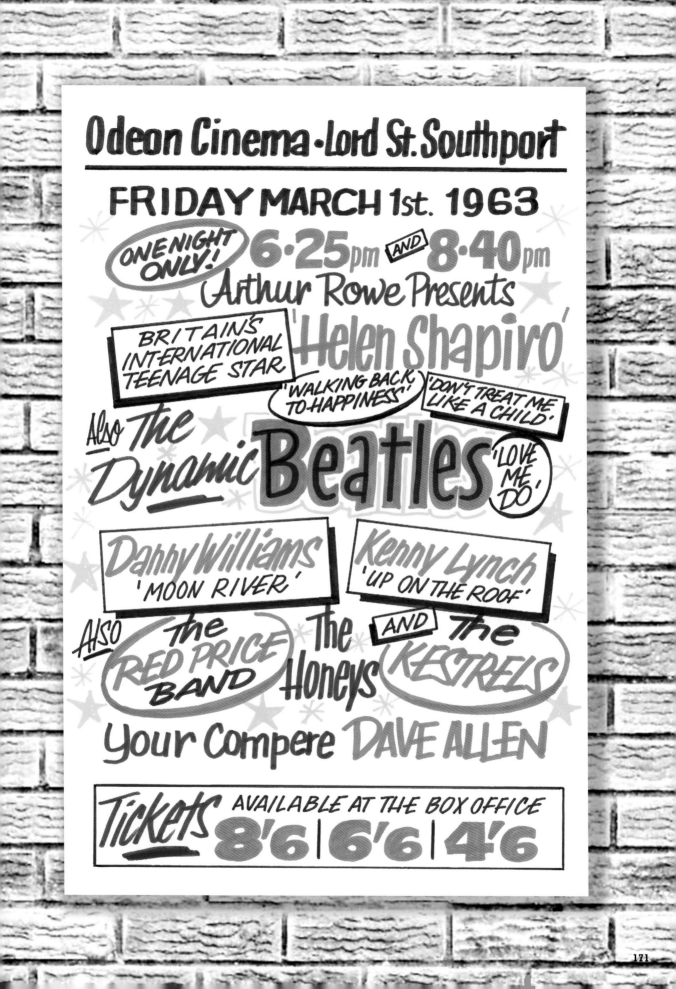

Tower Ballroom, New Brighton
Friday 14 June 1963

Two well-known posters follow of the Beatles' last ever appearance at the Tower in New Brighton on Friday 14 June 1963.

This was a Brian Epstein (NEMS Enterprises) presentation, with Bob Wooler in charge of production. It was the Beatles' last performance at one of their favourite places, the Tower Ballroom, New Brighton. The Beatles, together with Gerry and the Pacemakers, topped the bill at this spectacular event. They were supported by five other top groups.

NEW BRIGHTON TOWER

FOR ONE NIGHT ONLY 7:30-11:30

MERSEYSIDE'S GREATEST!! **FRI. JUNE 14th**

THE ★ BEATLES

AND GERRY And The PACEMAKERS

PLUS 5 GREAT SUPPORTING GROUPS...

TICKETS 6'. IN ADVANCE

AT DOOR ON NIGHT 7'. A BOB WOOLER PRODUCTION

DON'T MISS *Friday June 28th* JET HARRIS & TONY MEEHAN

Tower Ballroom, New Brighton
Friday 14 June 1963

The Beatles were also booked to perform at Knotty Ash village hall in Liverpool that evening. They played their first spot at the Tower at 8 p.m. before racing to Knotty Ash. They then had to race back again for their last spot at the Tower later on at 11.30 p.m.

NEMS ENTERPRISES PRESENT AT
NEW BRIGHTON TOWER
FOR ONE NIGHT ONLY 7·30 to 11·30
FRIDAY, JUNE 14th.
"Merseyside's Greatest..."

THE
BEATLES
AND
GERRY *and the*
PACEMAKERS

TICKETS
6/-
IN ADVANCE

AT DOOR ON NIGHT
7/-

PLUS 5 GREAT SUPPORTING GROUPS!!

A BOB WOOLER PRODUCTION

DON'T MISS

FRIDAY, JUNE 28th.
JET HARRIS & TONY MEEHAN

Grafton Ballroom, Liverpool
Friday 2 August 1963

The Beatles performed at the Grafton Rooms on four occasions, including this, their final appearance there, on Friday 2 August 1963. The Grafton Rooms was one of Liverpool's two major ballrooms along with the Locarno Ballroom. They were located next door to one another.

Stanley Stadium, Liverpool
Saturday 31 August 1963

This spectacular event at the Liverpool Stanley Stadium on Saturday 31 August 1963 featured possibly the biggest bill of Merseybeat acts ever. It was 13 hours of non-stop live music, headed by Beryl Marsden and The Renegades, which ensured that this was truly a night to remember.

13 Hours Non-stop Beat

10·30am -11·30pm

SATURDAY AUGUST 31st 1963

Stanley Stadium, Prescot Road, Fairfield, Liverpool.

BERYL MARSDEN and The Renegades	
Billy J. Kramer AND THE DAKOTAS	Lee Curtis AND THE ALL STARS
The Undertakers	Freddy Starr AND THE MIDNIGHTERS
The BIG THREE	The SEARCHERS
The ESCORTS	The VIBRATORS
Johnny Sandon AND THE REMO FOUR	Mark Peters AND THE SILHOUETTES
Pete McLain AND THE CLAN	Sonny Webb AND THE CASCADES
Earl Preston AND THE TT's	Ian & The Zodiacs
Alex Korners BLUES INC	The Hollies

Chris Nava COMBO	John Leyton	THE Young Ones	RICKY VALANCE
MIKE SARNE	THE Easy Beats	THE PANTHERS	THE NOMADS

TICKETS IN ADVANCE 12/6 OR £1 ON DAY

SAE TO: JACARANDA ENTERPRISES 108 SEEL STREET, LIVERPOOL. OR ON SALE AT: NEMS-WHITECHAPEL, LIVERPOOL Sponsored by: THE DAILY HERALD

Astoria, London
Tuesday 24 December to Tuesday 31 December 1963

The Beatles Christmas Show was conceived and presented by Brian Epstein. It ran from 24 to 31 December. There was no show on Christmas Day (or on 29 December), so the Beatles and the other Merseyside acts returned to Liverpool in a private Viking aircraft, which Brian Epstein had chartered at a cost of £400. They were thus able spend Christmas Day with their families before returning to London on Boxing Day.

Odeon Cinema, Liverpool

Saturday 26 December 1963 to Saturday 2 January 1964

Brian Epstein presented the Gerry's Xmas Cracker stage show at the Odeon Cinema in Liverpool. The show was produced by Peter Holland, and Johnny Hackett was the compère. Gerry and the Pacemakers headed the bill supported by The Hollies. The other supporting groups included The Remo Four and The Fourmost.

The Beatles did not play at this event, as Brian Epstein had booked them for another Christmas show at the Astoria in London.

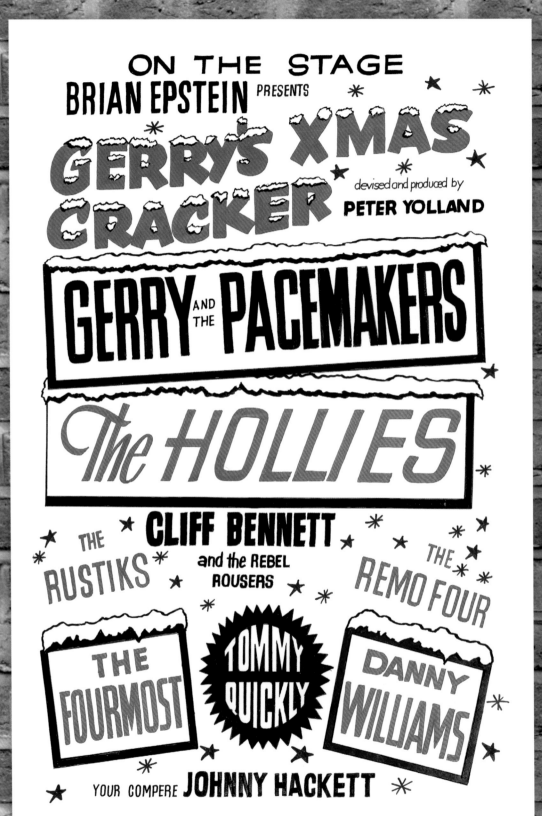

Cavern Club, Liverpool
Thursday 6 February 1964

During lunchtime on 6 February 1964, a special one-off recording session was arranged at the Cavern Club featuring Beryl Marsden, The Marauders and The Four Just Men. Tony was asked to produce a poster to get people in to support the performances.

LUNCH TIME
at The Cavern
10 MATHEW ST. LIVERPOOL 2

PRESENTS

DECCA RECORDING Session

Beryl Marsden

The MARAUDERS

THE FOUR JUST MEN

Thursday 6th. Feb. 1964

'Decca' will be recording the day's session!!

Birkenhead Technical College, Wirral
Saturday 6 February 1965

This poster was created for locally based R&B band The Prowlers, for their appearance at Birkenhead Technical College on 6 February 1965. The Prowlers were very popular at other Merseyside venues, appearing at the Cavern Club and the Tower Ballroom.

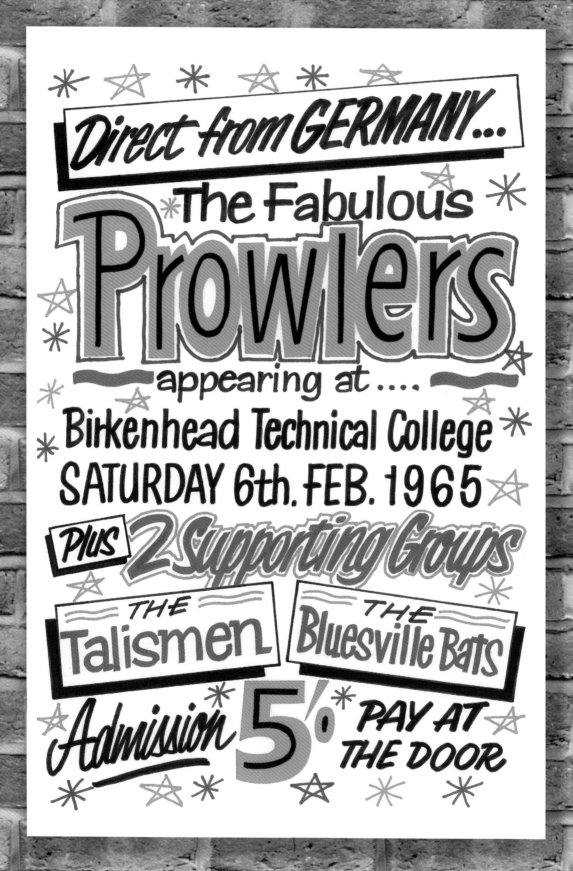

Cavern Club, Liverpool
16 January 2017

This was the last poster Tony Booth produced for the Cavern Club, during the summer of 2016 in preparation for the club's 60th anniversary celebrations in January the following year. It really showcases the range of styles and the creativity of a unique, unsung lettering artist who certainly played an important part in the marketing of music history. Posters and flyers were the social media of the sixties, and they helped create the legends of the era.

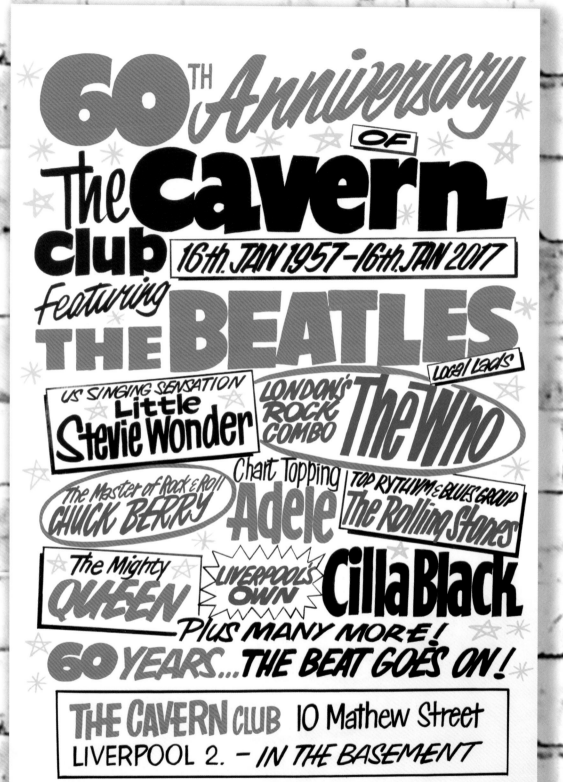

This is the last piece of lettering ever produced by Tony Booth. He completed this piece for the BBC only hours before being admitted to hospital. A week later Tony passed away peacefully with his family at his side after a long battle with cancer.

He designed this logo for a BBC documentary to celebrate the 60th Anniversary of the Cavern Club. The BBC produced a time-lapse film of him creating the lettering, which can be seen on his website thebeatlesposters.com

THE CAVERN — THE MOST FAMOUS CLUB In the World

Acknowledgements

WITH TONY'S passing in January 2017 during the creation of this book, his son Lee Booth and grandson Thomas Booth worked together to ensure that it was completed and ready to be published. On behalf of the family, they would like to thank Ray O'Brien, a close friend of Tony, for his help verifying the history and words for each poster that Tony wrote. Also, thanks to the Cavern Club for giving permission to publish their 60th Anniversary poster in this book.